994 North,Peter
NOR

Welcome to Australia

DEMCO

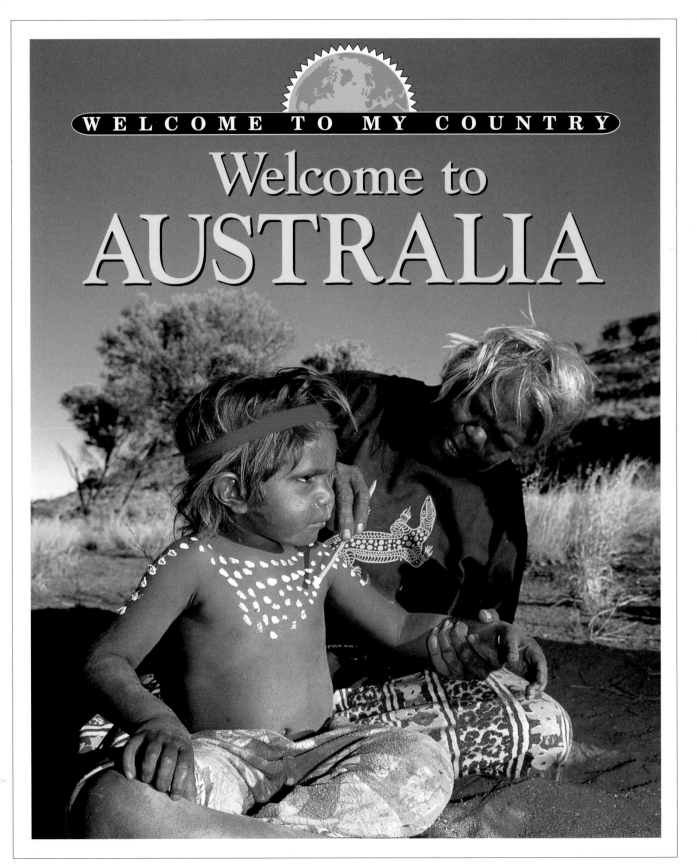

WELCOME TO MY COUNTRY

Welcome to
AUSTRALIA

Gareth Stevens Publishing
MILWAUKEE

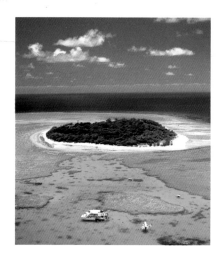

Written by
Peter North/Susan McKay

Designed by
Tuck Loong

Picture research by
Susan Jane Manuel

First published in North America in 1999 by
Gareth Stevens Publishing
1555 North RiverCenter Drive, Suite 201
Milwaukee, Wisconsin 53212 USA

For a free color catalog describing
Gareth Stevens Publishing's list of high-quality books
and multimedia programs, call
1-800-542-2595 (USA) or
1-800-461-9120 (CANADA).
Gareth Stevens Publishing's
Fax: (414) 225-0377.

© **TIMES EDITIONS PTE LTD 1999**
Originated and designed by
Times Books International
an imprint of Times Editions Pte Ltd
Times Centre, 1 New Industrial Road
Singapore 536196
http://www.timesone.com.sg/te

Library of Congress Cataloging-in-Publication Data

North, Peter, 1943–
Welcome to Australia / Peter North and Susan McKay.
p. cm. — (Welcome to my country)
Includes bibliographical references (p. 47) and index.
Summary: An overview of the country of Australia that includes
information on geography, history, government, the economy, people,
and lifestyles.
ISBN 0-8368-2393-1 (lib. bdg.)
1. Australia—Juvenile literature. [1. Australia.]
I. McKay, Susan. II. Title. III. Series.
DU96.N68 1999
919.4–dc21 98-54729

Printed in Malaysia

1 2 3 4 5 6 7 8 9 03 02 01 00 99

PICTURE CREDITS
A.N.A. Press Agency: 3 (center), 24, 30
Peter Andrews: 17, 39
Camera Press Ltd: 8 (bottom), 13, 32, 33,
 37 (both)
Hoa-Qui: 3 (top), 6, 8 (top), 21, 25, 34, 40
Dave G. Houser: 9, 27, 31, 36
Hutchison Library: 1, 4
Richard l'Anson: 23, 41, 45
Life File Photo Library: 7 (bottom), 16,
 28, 35
Photobank Photolibrary/Singapore: cover,
 2, 3 (bottom), 5, 7 (top), 10, 18
Topham Picturepoint: 11, 12, 14, 15 (both),
 19, 20, 29 (both), 38
Travel Ink: cover, 22
Trip Photographic Library: 26

Digital Scanning by Superskill Graphics Pte Ltd

Contents

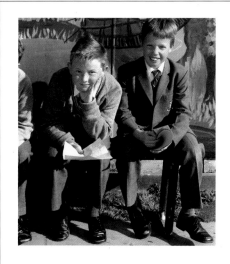

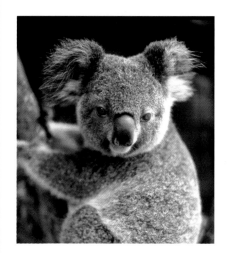

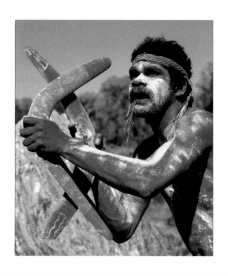

Words that appear in the glossary are printed in **boldface** type the first time they occur in the text.

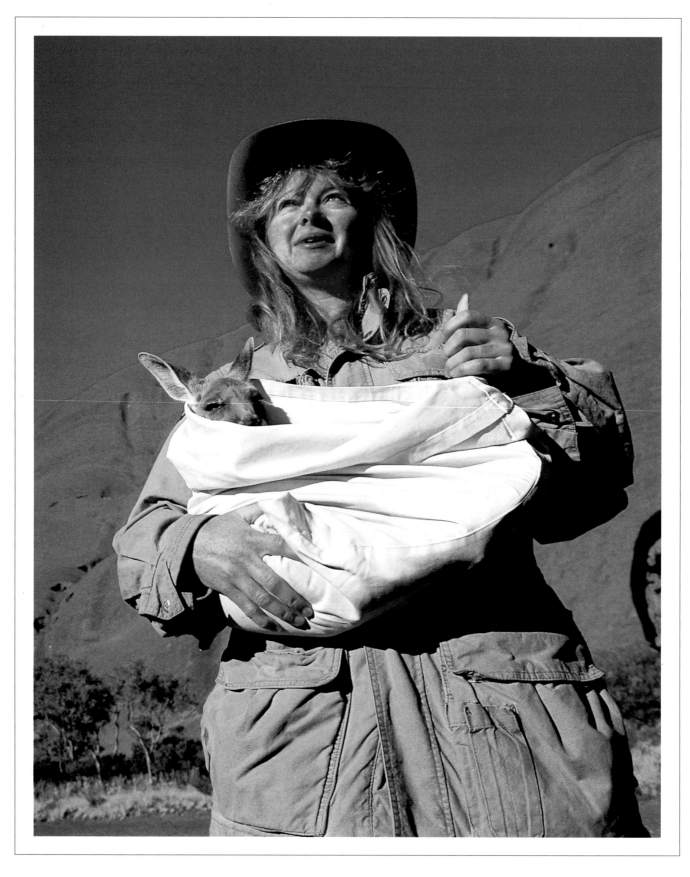

Welcome to Australia!

Many people imagine Australia as a large island with good weather all year round. More than half the country is covered in desert, but Australia has **temperate** and **tropical** climates, too. Let's learn all about the country called "**down under**" and the history of the people who live there.

Opposite: A park guide cares for an orphaned kangaroo.

Below: Most Australian cities are along the coast, so the beach is never far away!

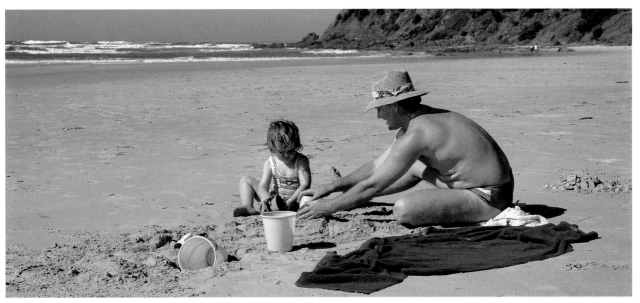

The Flag of Australia

The Australian flag carries the stars of the Southern Cross. This **constellation** is only visible in the **Southern Hemisphere**, where Australia is located. The flag of the **United Kingdom** appears in the top left corner.

The Land

Australia is almost as large as the United States, not including Alaska. Most people live in the big cities around the edges of the country.

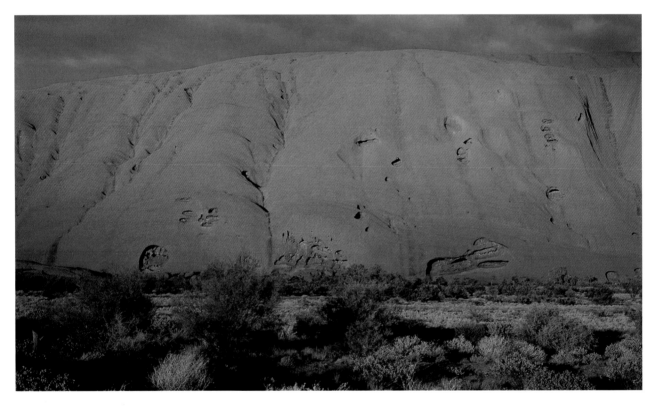

Sydney, Melbourne, Brisbane, and Perth all dot the Australian coast. The land formations change from region to region. Hardly anyone lives in the dry, central region called the **outback**, or **bush**, called the "Dead Heart."

Above: Uluru, or Ayers Rock, is an enormous sandstone rock in the Northern Territory. It is a sacred site for the **Aborigines**, Australia's original inhabitants.

The eastern and southern coastlines, northern Australia, and the southwestern region have rich, fertile land that is good for farming.

Most of Australia is very flat. The highest mountain is Mount Kosciusko (7,310 feet/2,228 meters) in the Great Dividing Range, which runs along the eastern coast.

The Murray is the longest river in Australia. It snakes through the state of New South Wales, collecting rainfall off the mountain slopes.

Above: The Great Barrier Reef is the world's largest coral reef. Corals live in warm, clear waters, such as those off the shores of tropical Queensland.

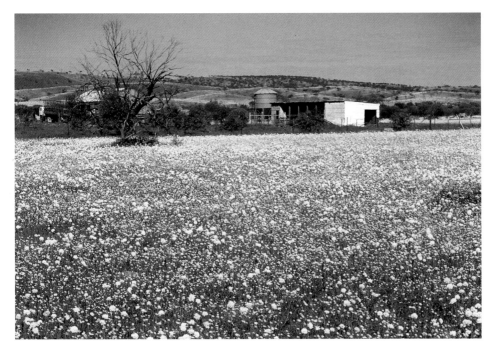

Left: Spring wildflowers cover the land in Western Australia.

Seasons

Australia lies in the Southern Hemisphere, where summer lasts from December to February. The climates of different regions range from dry and hot, to mild and wet.

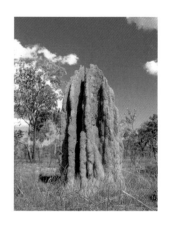

Above: This giant termite mound is made of mud. It is home to millions of termites — tiny ant-like insects that feed on wood.

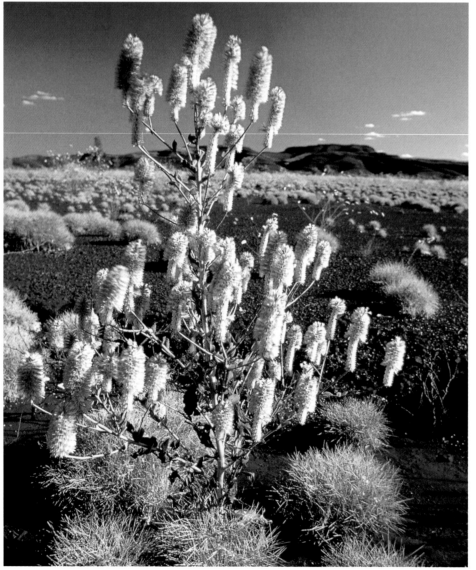

Left: In Australia's deserts, many flowers bloom after heavy rains. The land can suddenly burst into a display of beautiful color.

Plants and Animals

Australia's famous animals include kangaroos, koalas, and opossums. These mammals are known as **marsupials**. The mothers carry their babies in a pouch for months.

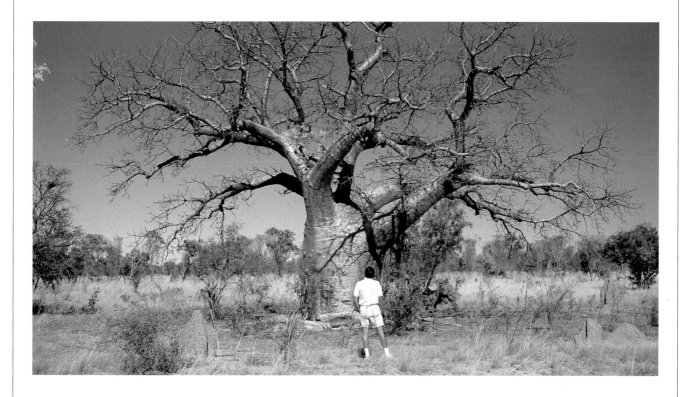

Special features help Australia's plants survive in its dry climate. Long roots help the eucalyptus tree seek out water, and the baobab tree stores water in its thick trunk.

Above: It would take several people to form a ring around the thick trunk of this baobab tree!

History

Australia's Original Settlers

The Aborigines came from Asia about 40,000 to 50,000 years ago and were the first people to settle in Australia. The men hunted land animals and fish, while the women gathered seeds, roots, and berries. When Europeans first arrived, there were about half a million Aborigines living across Australia.

Below: Boomerangs (BOO-muh-rangs) are *V*-shaped objects used by Aboriginal hunters.

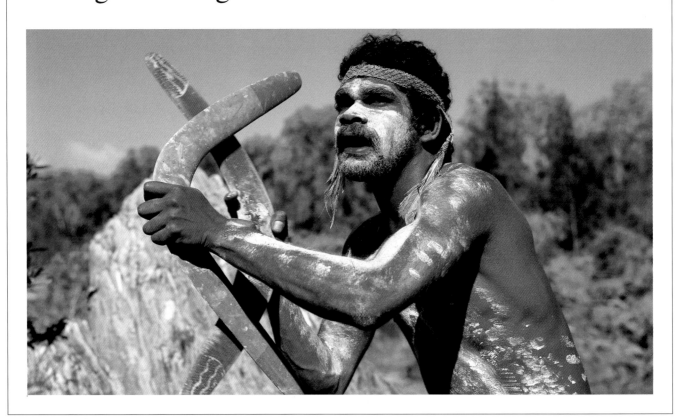

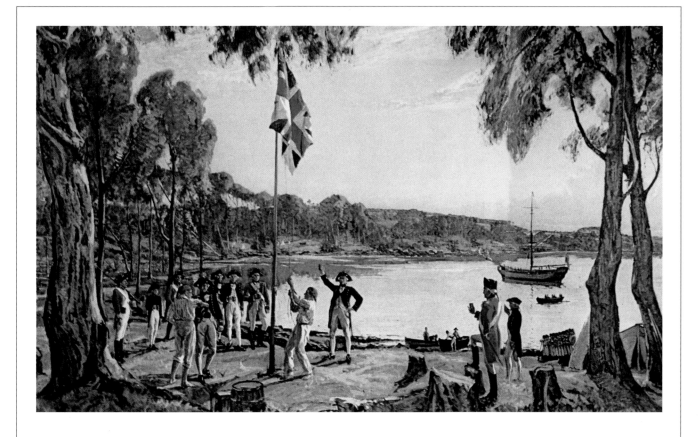

The Europeans Arrive

Just over two hundred years ago,
European sailors landed on the coasts
of Australia. In 1770, British explorer
James Cook claimed the eastern coast
of Australia for his king, George III.
For many years afterward,
Britain sent **convicts** there. New
settlements were also established on
the southern coast of Australia and
on the island of Tasmania.

Above: In 1788,
the British raised
their flag at
Sydney Cove.

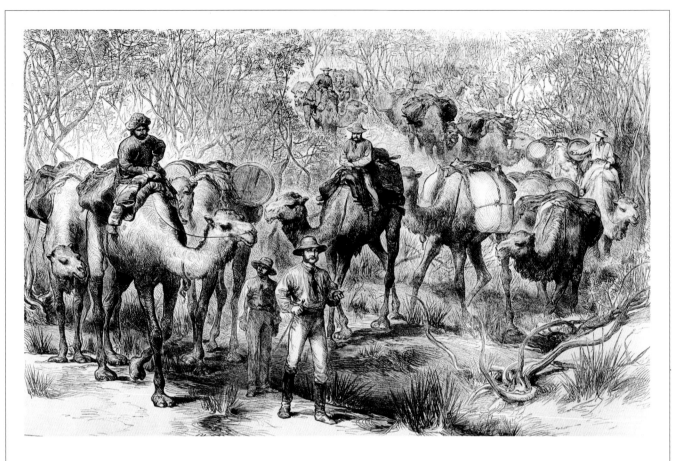

A Land of New Possibilities

Before long, **immigrants** were coming to Australia in large numbers, mainly from England and Ireland. They introduced new ways of farming and mining. They even brought a new animal with them in 1810 — the sheep! Soon, Australia was a rich country with a successful wool industry. Australia had become a land with many new possibilities.

Above: In the early 1800s, the new settlers began exploring Australia on camels.

The Commonwealth of Australia

At the beginning of the twentieth century, there were six Australian territories, called colonies, inhabited by immigrants.

In 1901, they joined to form a **federation** called the Commonwealth of Australia. Australia still had strong links with Britain, and Australians fought alongside the British in World Wars I and II. The Australian and New Zealand soldiers who fought in the World Wars were called ANZACs.

Left: This memorial in Brisbane is dedicated to the ANZAC soldiers who died fighting a famous battle during World War I.

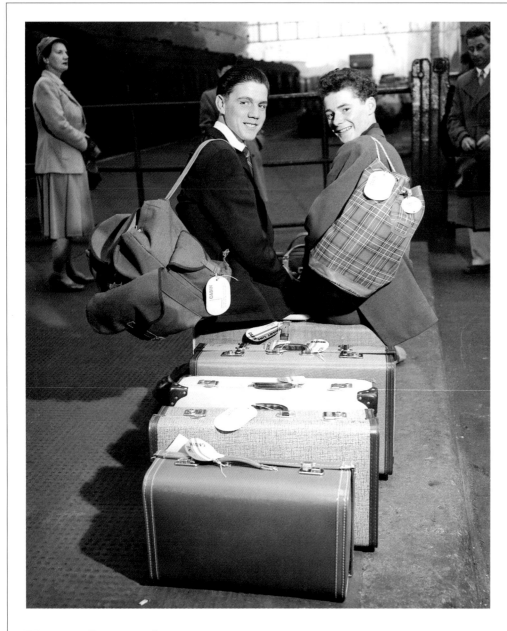

Left: These two young men emigrated from London to Sydney in 1959. They were two of the many Europeans who settled in Australia.

Immigration

Since World War II, Australia has encouraged immigration. Today, Australia is known as an immigrant country because many people living there were born elsewhere.

Matthew Flinders (1774–1814)

Matthew Flinders was a famous English explorer. In 1801, he proved that Australia was a single landmass by sailing all the way around the coast. At that time, Australia was known as **New Holland**. He suggested renaming it *Australia,* from the Latin word *australis,* meaning "southern."

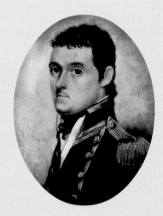

Matthew Flinders

Caroline Chisholm (1808–1877)

In the early 1800s, poor women from Britain came to Australia to find a better life. Many of them had no money and lived on the streets. Caroline Chisholm set up the Female Immigrants' Home to help those women. Soon, she was known across the country as "the immigrant's friend." She helped more than ten thousand women.

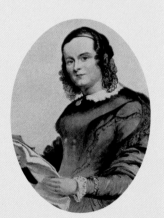

Caroline Chisholm

Government and the Economy

Government

Australia is divided into six states and two territories. Its government is divided into three sections — the

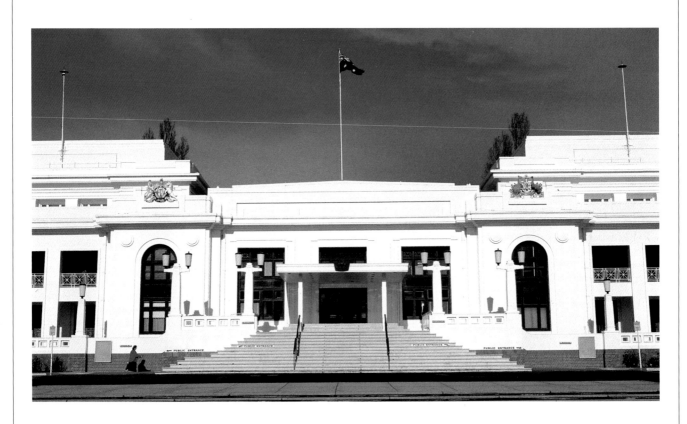

town and city councils, the state and territory governments, and the federal government, which is based in Canberra, the capital city.

Above: The old Parliament House is in Canberra, the capital city of Australia.

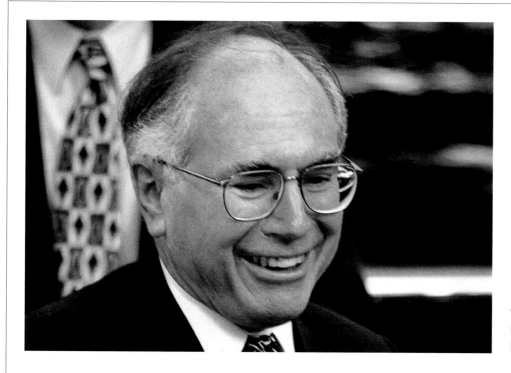

Left: John Howard was elected prime minister of Australia in 1996.

Australia's government is run by two houses of elected members — the House of Representatives and the Senate. Together, they decide on laws and government policies. The **prime minister** is the leader of the government and the country. He or she chooses politicians from either house to form a group called the **cabinet**. Each cabinet member, called a minister, is in charge of one area of government. These ministers advise the prime minister.

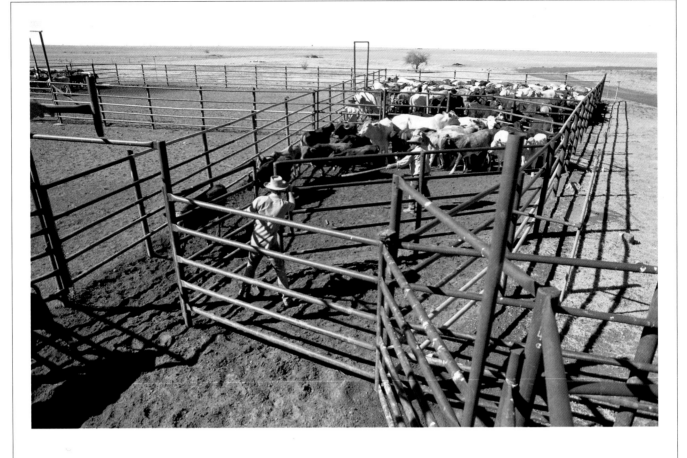

Agriculture

In the 1800s, the main industry in Australia was sheep farming, and Australia is still the world's largest wool-producing country. Cattle farming is important, too, and produces beef for both the nation and for export. Some cattle stations stretch for miles and miles. Teams of men, trucks, and even helicopters round up the herds.

Industry

In the nineteenth century, ships took months to bring goods to Australia, forcing Australians into making the things they needed for themselves. The Australian manufacturing industry began in this way.

Mining

Australia contains many natural resources. Gold, coal, iron ore, copper, and nickel are mined in many regions. Under the ocean, natural gas is drilled and sold to other countries.

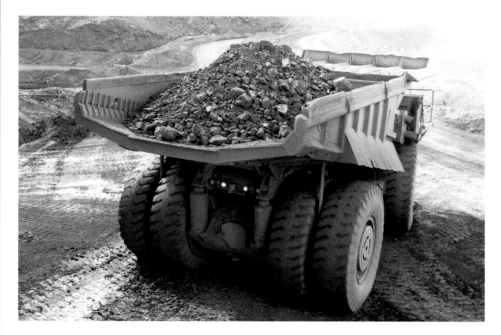

Left: Iron ore is one of the major minerals found in Western Australia, along with gold, tin, coal, and diamonds.

People and Lifestyle

More Travelers Arrive!

Since the first settlers arrived, many immigrants have moved to Australia. Most people emigrated from Britain, but others traveled from Italy, Greece,

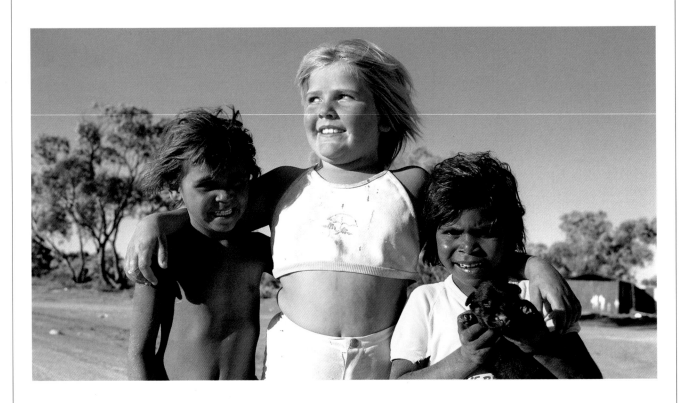

China, Vietnam, and Lebanon. The original people of Australia, the Aborigines, make up a very small part of the population.

Above: Immigrant Australians and Aborigines have not always been friends, but the situation has begun to improve.

A Melting Pot

In Australia, many races of people live together in one land. The government has introduced a **policy** called "**multiculturalism**," which encourages ethnic groups to live peacefully with one another.

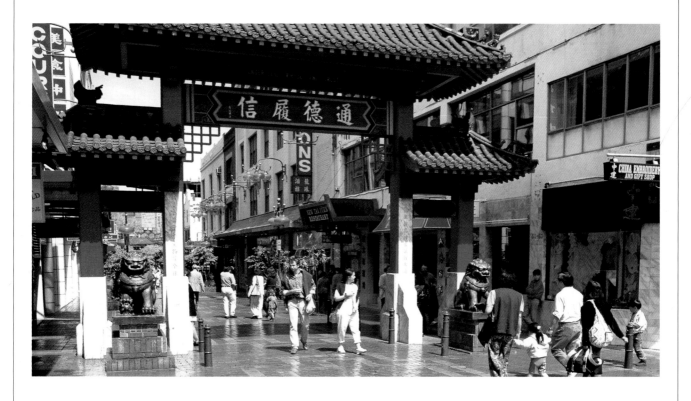

Many immigrants from Asian countries arrived in Australia in the 1970s, and, today, most Australian cities have large Asian communities.

Above: Many Chinese immigrants live in the part of Sydney called Chinatown.

Family Life

Most Australians live in homes in a town or city not far from the coast. Outdoor activities are popular with Australians, and the sunny climate allows them to visit the beach as often as they can.

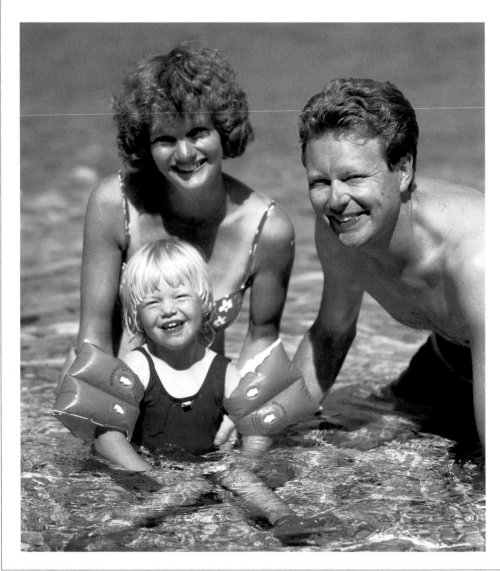

Left: Going to the beach is a favorite weekend activity. Most children learn to swim when they are very young.

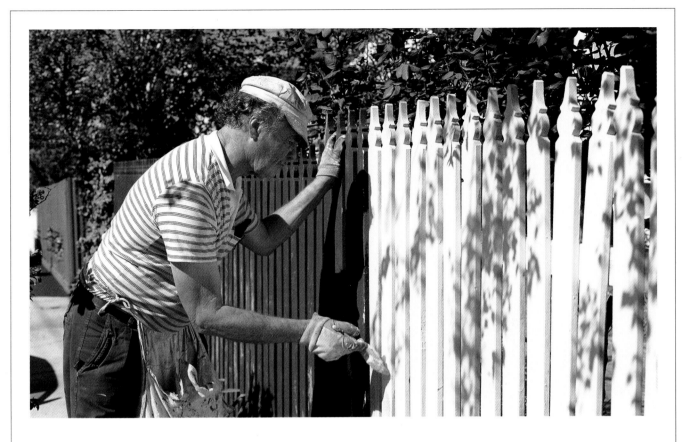

Australia is a big country with a fairly small population, so most of the houses in the cities are large, with gardens at the front and back. Neighborhoods are friendly, and most people know each other.

Australians are proud of their homes, and they take care of them well. Weekend projects might include painting a fence, mowing the lawn, or working in the garden.

Above: Home improvement is a typical Sunday afternoon chore in Australia.

Education

All Australian children must attend school, starting at either five or six years of age. They attend primary school and secondary school. Primary school lasts six years. Students then go to secondary school, which lasts another six years.

Most schools are run by the government and are free. Some parents send their children to private schools, which they pay for.

Below: Children who live in **rural** areas must take a bus to and from school.

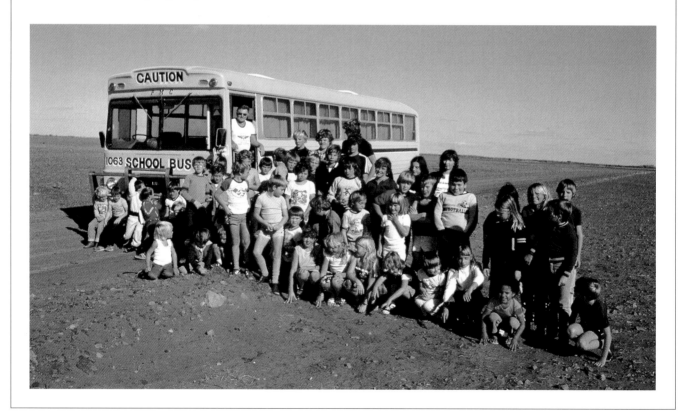

After secondary school, students can further their education by attending technical institutions, community colleges, or universities.

Australian schools offer activities, such as drama, debating, and music, after classes are through. Sports are popular at school, too. Students can join clubs to play Australian Rules football, hockey, netball, and cricket.

Above: Some Australian children have to wear a school uniform.

Religion

Christianity came to Australia with the European settlers, and it is the main religion in the country today.

Before the Europeans arrived, the Aborigines practiced their own religion. They believed the spirits of their ancestors lived in the trees, water holes, and rocks. Some Aborigines today still hold this belief.

Below: These poles, decorated with carvings and paintings, are placed around Aboriginal graves to honor family members.

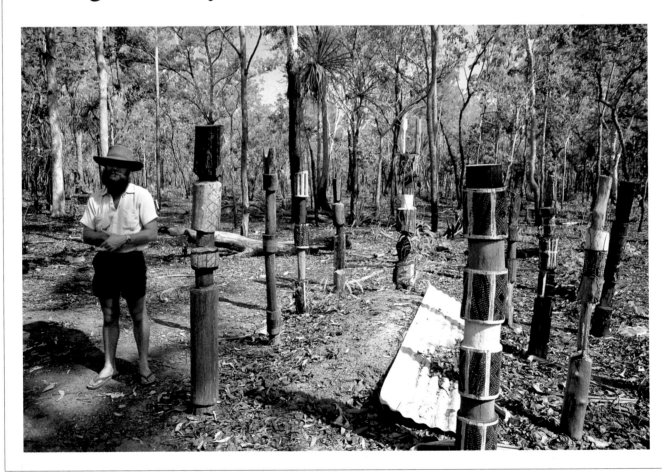

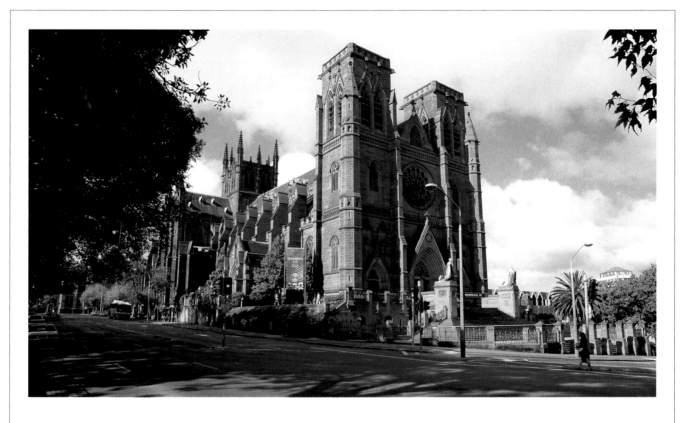

The Arrival of Christianity

The Europeans brought Christian beliefs with them from other countries and built churches all over Australia. Some of the first buildings in a town were churches. Immigrants from other countries brought their own religions, too. **Passover**, a Jewish festival, and Hari Raya, a Muslim festival, are also celebrated. Today, there are Hindus, Buddhists, and Sikhs in Australia.

Above: Sydney has many Christian churches. This is St. Mary's Cathedral.

Language

A Mixed Language

The main Australian language is English, spoken by most citizens with an accent handed down by the original settlers from England and Ireland. Immigrants from European and Asian countries brought their own languages with them. Over the years, Australians have adopted some Aboriginal words, such as *Illawarra,* meaning "place by the sea."

Below: This beach sign is in English, Spanish, Italian, Russian, Vietnamese, and Chinese.

Australian Stories

Traditional Australian stories tell of the lives of the people who lived in the outback. A man named A. B. "Banjo" Patterson was the first Australian to write about the outback. He wrote about the men who herded cattle for thousands of miles.

The stories of the outback are still being told by modern-day writers, such as Australian Colleen McCullough. She wrote the best-selling book *The Thorn Birds*.

Above, left:
In 1973, Patrick White was the first Australian to win the Nobel Prize for Literature.

Above, right:
Peter Carey won the 1988 Booker Prize for Fiction for his book *Oscar and Lucinda*.

Arts

Painting

The oldest paintings in Australia were done by the Aborigines. They decorated cave walls with pictures of animals and people using natural materials, such as charcoal.

European settlers brought their own style of painting to Australia, and many famous Australian artists now mix the two styles together.

Below: The colors of this cave painting are typical of Aboriginal art.

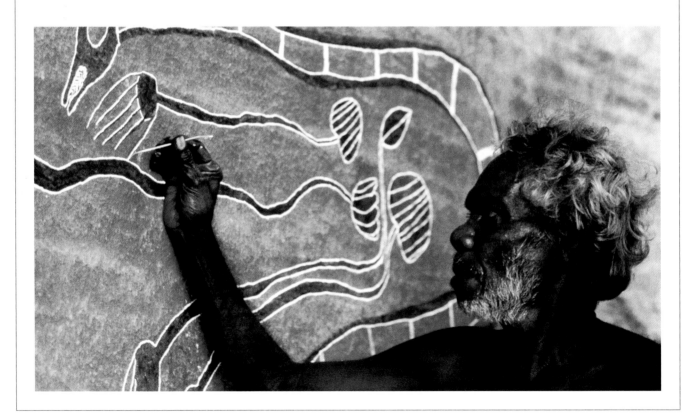

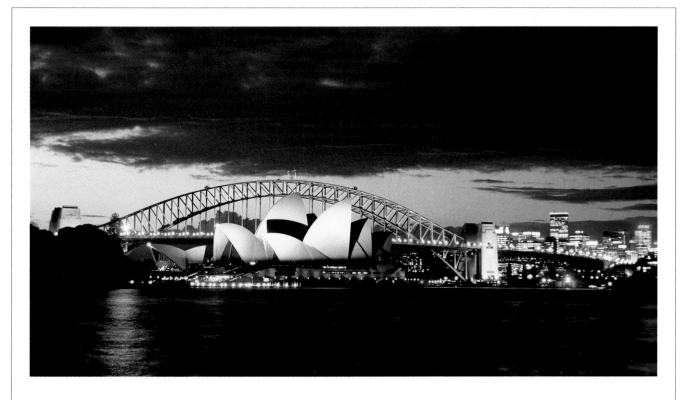

Architecture

The Harbour Bridge and the Sydney Opera House are two of Australia's most famous structures. Sydney Harbour is divided by a waterway. The Harbour Bridge joins the two halves of the harbour together.

The Sydney Opera House is one of the busiest theaters in the world, presenting plays, operas, musicals, and ballets. Architects and craftspeople took fourteen years to complete it.

Above: People living in Sydney call the bridge "The Coat Hanger" because of its unusual shape.

Music

Australians love making music! Have you heard of the rock bands the Bee Gees, AC/DC, Midnight Oil, and INXS? Or how about the opera singers Dame Nellie Melba and Dame Joan Sutherland, known as two of the world's best performers? These musical stars all come from Australia.

Left: Dame Joan Sutherland sang in operas in Venice, Paris, Milan, and New York, as well as in her hometown, Sydney.

Australian Films

The film *Babe: Pig in the City* is the most recent Australian movie to be an international box office hit. *Crocodile Dundee*, about an outback man who moves to New York City, is probably the best-known Australian film. Every year, many films are made in Australia. *The Piano*, directed by Australian Jane Campion, received worldwide acclaim, winning several international awards.

Above: *Crocodile Dundee* **was filmed in Australia and the United States. The movie's lead actor, Paul Hogan, is a native Australian.**

Leisure

A Love of the Outdoors

Australia's climate is perfect for spending time outdoors. Australians love to watch and play sports, such as rugby and Australian Rules football. Fishing is a very popular Australian pastime. It gives people a chance to get away from the hustle and bustle of the city. The great thing is, the water is never far away!

Below: The waters of the Northern Territory are popular with fishing fans.

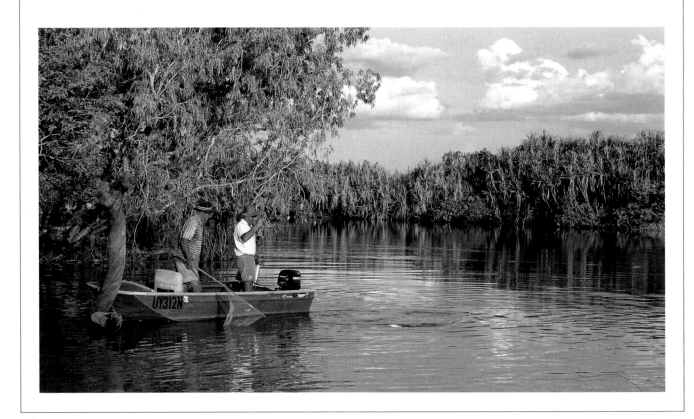

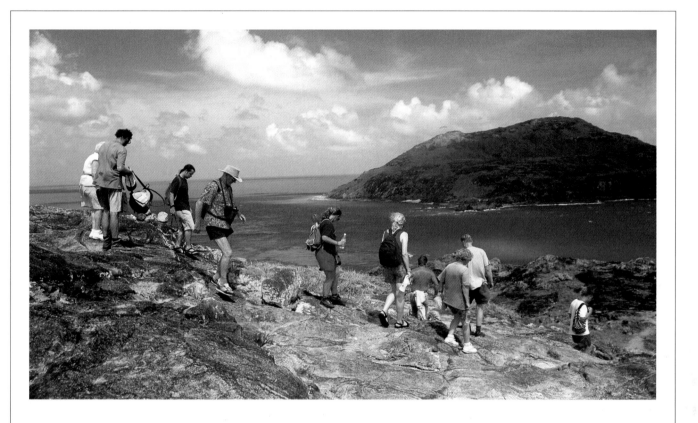

Outdoor Adventures

Many Australians like to go **bush-walking**, and there are trails throughout most of the country.

Most Australians live near the coast. They love swimming and surfing. The country is surrounded by water, and there are plenty of great surfing spots on the coast. There is even a beach in Australia called Surfer's Paradise!

Sports

Cricket is one of the best-loved sports in Australia. Children and adults play this game in backyards, fields, and **sporting ovals**.

Australian Rules football is the main winter sport. It is known as "Aussie Rules" and is a cross between rugby and basketball.

Australians have a holiday on the day of the Melbourne Cup. Numerous people can then watch this famous horse racing event.

Below: On Melbourne Cup day, the racecourse is packed with excited spectators. In the rest of the country, people watch the race on television.

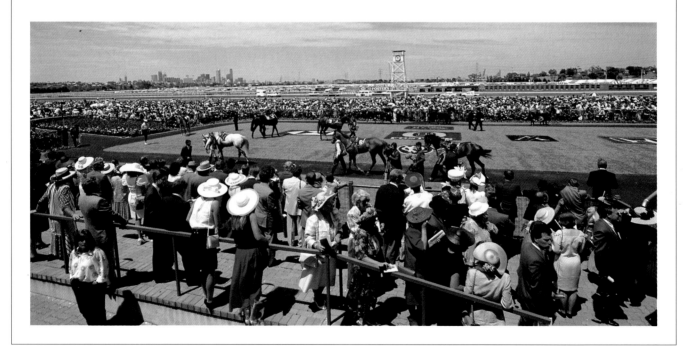

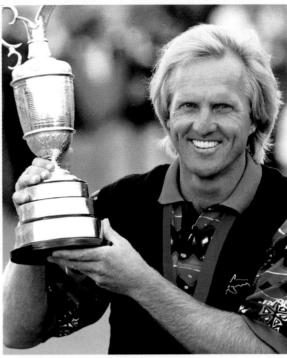

Australian Champions

One of the most famous Australian sports champions is golfer Greg Norman. In 1971, Yvonne Cawley became the first Aboriginal tennis player to win the Wimbledon championship. She won it again in 1980. Pat Rafter won the 1997 U.S. Open Tennis Championship. Aborigine Cathy Freeman won a silver medal in the 400-meter run at the 1996 Olympics.

Above, left:
Tennis player Yvonne Cawley won at Wimbledon in 1971 and 1980.

Above, right:
Golfer Greg Norman has won many international competitions.

Holidays

Christmas is the biggest holiday in the Australian calendar. It falls at the beginning of summer and marks the end of the school year. Some people celebrate the holiday on the beach and have a barbecue with a turkey and all the trimmings!

Anzac Day is on April 25. It is a day to remember the ANZAC soldiers who lost their lives in war. **Veteran** soldiers parade through the streets wearing their uniforms.

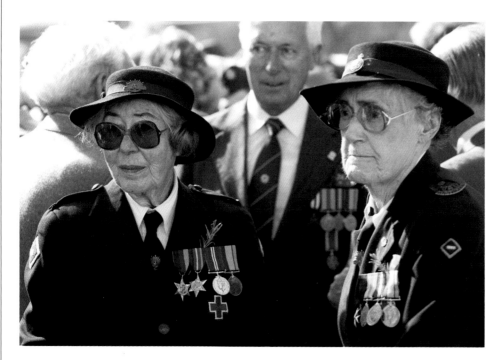

Left: The Anzac Day parade. These nurses are wearing a sprig of rosemary, the herb of remembrance, above their medals.

January 26 is Australia Day. It marks the day the first group of immigrants arrived in the country. People all over Australia celebrate by singing the national anthem and setting off fireworks!

Every year, each state holds an agricultural show. Prizes are awarded for the best cows, the biggest bulls, and the sheep with the finest **fleece**. Other contests include the log chop and the high pole, where loggers race to chop the top off tree trunks while balancing on narrow planks.

Above: The log chop is a race to see who can chop a log in half the quickest.

Food

Immigrants brought national dishes with them, and today foods from many other countries are available — pasta from Italy, olives from Greece, curries from India, and **kebabs** from Turkey. Recently, traditional Aboriginal foods have become popular, too.

Left: This Aboriginal woman is holding a *wichetty* (WICH-ah-tee) *grub*. These fat, white, slug-like creatures are popular in trendy Sydney restaurants!

In the outback, food is very simple. The traditional diet is **damper** and tea. Damper is flour and sugar mixed with water, cooked over an open fire.

During the summer, many Australians cook on a barbecue pit. They call it a *barbie* (BAH-bee). The most popular barbecued foods are

Below: There are plenty of public barbecue pits in Australia.

meats and seafood. Barbecued vegetables are delicious, too. A barbecue on the beach is a popular way to celebrate Christmas.

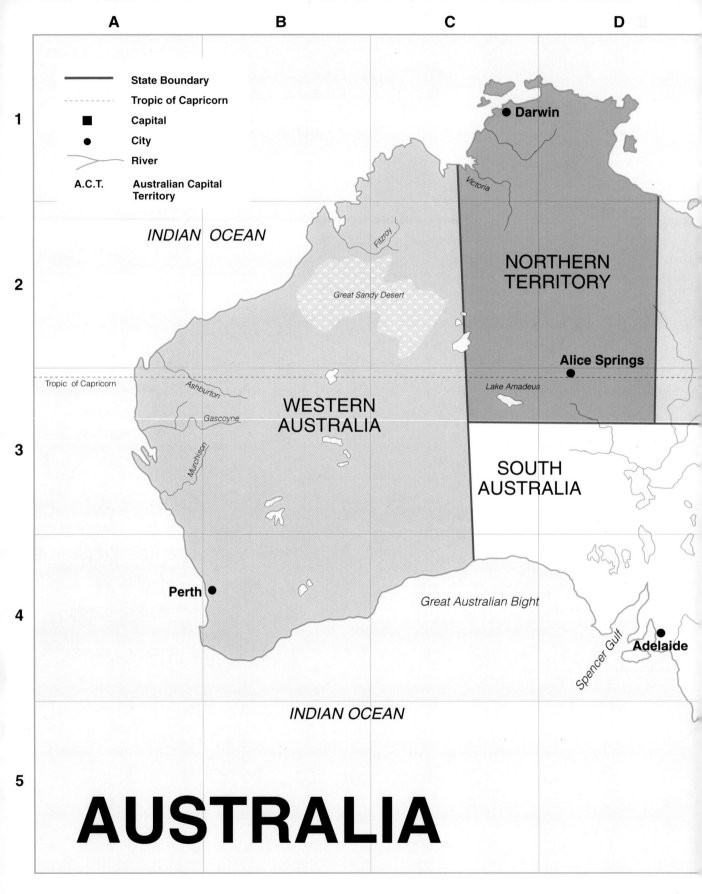

AUSTRALIA

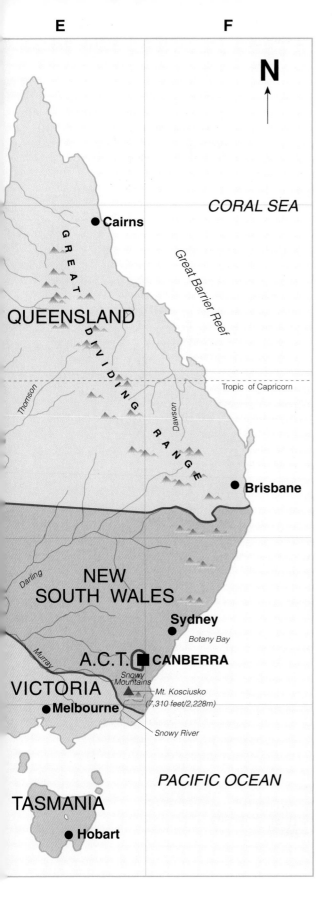

	E	F

N

CORAL SEA

● Cairns

Great Barrier Reef

G R E A T D I V I D I N G R A N G E

QUEENSLAND

Thomson

Dawson

Tropic of Capricorn

● Brisbane

Darling

NEW
SOUTH WALES

Sydney

Botany Bay

Murray

A.C.T. CANBERRA

VICTORIA

Snowy
Mountains

Mt. Kosciusko
(7,310 feet/2,228m)

● Melbourne

Snowy River

PACIFIC OCEAN

TASMANIA

● Hobart

Adelaide D4
Alice Springs D3
Amadeus, Lake C3
Ashburton River A3
Australian Capital
 Territory (A.C.T.)
 E4

Botany Bay F4
Brisbane F3

Cairns E2
Canberra E4
Coral Sea F2

Darling River E4
Darwin C1
Dawson River F3

Fitzroy River C2

Gascoyne River B3
Great Australian
 Bight C4
Great Barrier Reef F2
Great Dividing Range
 E2–F3
Great Sandy Desert
 B2

Hobart E5

Indian Ocean A2–B5

Lachlan River E4

Melbourne E5
Mount Kosciusko E4
Murchison River A3
Murray River E4

New South Wales E4
Northern Territory C2

Pacific Ocean F5
Perth B4

Queensland E2

Snowy Mountains F5
Snowy River F5
South Australia C3–D3
Spencer Gulf D4
Sydney F4

Tasmania E5
Thomson River E3
Tropic of Capricorn A3

Victoria E4
Victoria River C1

Western Australia B3

Quick Facts

Official Name Australia

Capital Canberra

Official Language English

Population 18,077,000 (1996 census)

Land Area 2,966,000 square miles/7,682,000 sq. km

States New South Wales, Queensland, South Australia, Tasmania, Victoria, Western Australia

Territories Australian Capital Territory, Northern Territory

Major Cities Adelaide, Brisbane, Cairns, Canberra, Darwin, Melbourne, Perth, Sydney

Highest Point Mount Kosciusko (7,310 feet/2,228 m)

Major River Murray River

Main Religion Catholicism (27 percent)

Major Festivals Australia Day, January 26

Anzac Day, April 25

Christmas, December 25

National Animals Emu, kangaroo

Currency Australian dollar (AUS $1.57 = U.S. $1 in 1999)

Opposite: This sign warns that camels, wombats, or kangaroos may be crossing ahead.

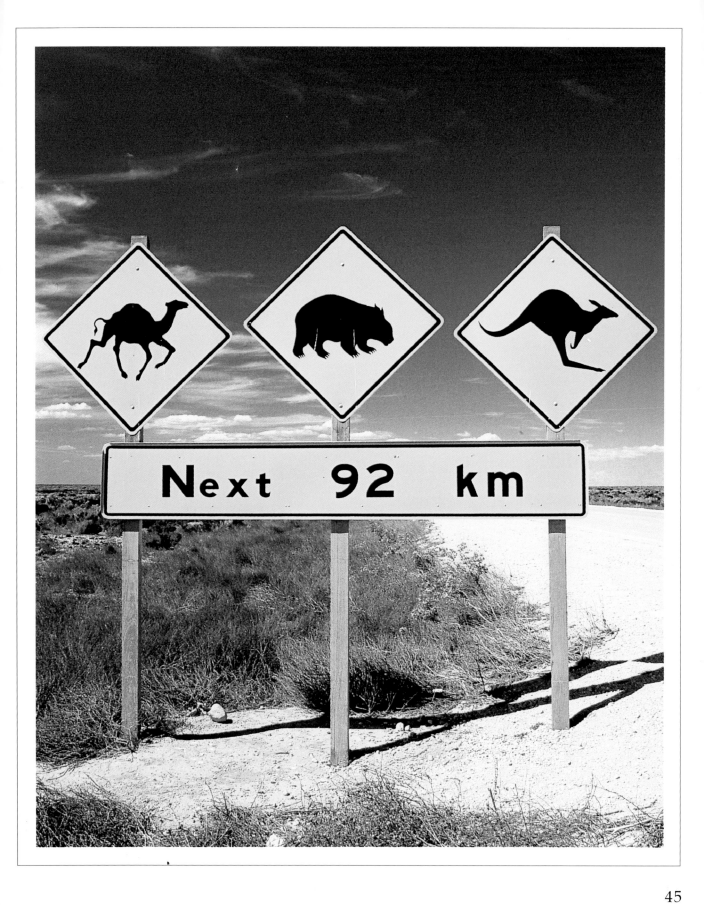

Glossary

Aborigines: the original people of Australia.

boomerang (BOO-muh-rang): a *V*-shaped hunting weapon used by the Aborigines.

bush: an area of forest, desert, or scrubland outside the main cities.

bush-walking: hiking in the bush.

cabinet: group of government ministers.

constellation: a group of stars forming patterns in the sky.

convicts: people who are serving a prison sentence.

damper: a dumpling made from flour, sugar, and water.

"down under": another name for the country of Australia.

federation: a group of governmental organizations.

fleece: a sheep's coat.

immigrants: people who live in a country they were not born in.

kebabs: chunks of meat and vegetables on skewers or wrapped in bread.

marsupials: animals whose young babies live in the mother's pouch.

multiculturalism: including many different countries and cultures.

New Holland: the former name of Australia.

outback: the central area of Australia.

Passover: a Jewish festival held in spring.

policy: a strategy or rule made by the government.

prime minister: the political leader of a country.

rural: relating to the countryside, away from towns and cities.

Southern Hemisphere: the southern half of Earth.

sporting oval: a field built for sports activities and competitions.

temperate: having a climate with four seasons.

tropical: having a climate with hot, sticky, wet weather all year round.

United Kingdom: England, Scotland, Wales, and Northern Ireland.

veteran: a former soldier.

witchetty grub (WICH-ah-tee GRUB): a small, white, slug-like creature.

More Books to Read

Aboriginal Paintings of Australia.
Carol Finley
(Lerner Publications)

Angel's Gate. Rebecca Davis
(Simon & Schuster Juvenile)

*Anzac Day: Australia's Forces
in War and Peace.* Jill B. Bruce
(Seven Hills Book Distributors)

Australia. Michael S. Dahl
(Capstone)

Australia. Festivals of the World series.
Diana Griffiths (Gareth Stevens)

*Hands Around the World. Williamson
Kids Can! (series).* Susan Milord
(Gareth Stevens)

Here is the Coral Reef. Madeline
Dunphy (Disney Publishers)

The Kimberley. Debbie Gallagher
(Heinemann Library)

Postcards From Australia.
Helen Arnold
(Raintree/Steck-Vaughn)

Reef of Death. Paul Zindel
(HarperCollins Juvenile Books)

Videos

Australia. (National Appraisal and
Consulting Association)

Babe. (Universal Studios)

Crocodile Dundee II.
(Paramount Studios)

G'day from Australia. (Brentwood
Entertainments)

The Man From Snowy River.
(Twentieth Century Fox)

The Piano. (Artizan Entertainments)

Web Sites

www.australianet.com.au

www.kangaroo-industry.asn.au

www.pnc.com.au/~wincom/sydney.htm

www.yahoo.com.au

Due to the dynamic nature of the Internet, some web sites stay current longer than others. To find additional web sites about Australia, use a reliable search engine and enter one or more of the following keywords: *Aborigines, Australia, boomerangs, Great Barrier Reef, marsupials, outback.*

Index

Art in Context

Piero della Francesca: The Flagellation

Art in Context

Edited by John Fleming and Hugh Honour

Each volume in this series discusses a famous painting or sculpture as both image and idea in its context – whether stylistic, technical, literary, psychological, religious, social or political. In what circumstances was it conceived and created? What did the artist hope to achieve? What means did he employ, subconscious or conscious? Did he succeed? Or how far did he succeed? His preparatory drawings and sketches often allow us some insight into the creative process and other artists' renderings of the same or similar themes help us to understand his problems and ambitions. Technique and his handling of the medium are fascinating to watch close up. And the work's impact on contemporaries and its later influence on other artists can illuminate its meaning for us today.

By focusing on these outstanding paintings and sculptures our understanding of the artist and the world in which he lived is sharpened. But since all great works of art are unique and every one presents individual problems of understanding and appreciation, the authors of these volumes emphasize whichever aspects seem most relevant. And many great masterpieces, too often and too easily accepted and dismissed because they have become familiar, are shown to contain further and deeper layers of meaning for us.

Art in Context

*Piero della Francesca, painter and mathematician, is first recorded on
7 September 1439 when he was working with Domenico Veneziano
in Florence. He was probably born between 1410 and 1420 in Borgo San
Sepolcro, the small town in Tuscany where he spent much of his
life and where he was buried on 12 October 1492. His father was a shoemaker.
He worked in Rimini, Ferrara, Urbino and Arezzo where he painted
the fresco cycle of* The Legend of the True Cross *in S.Francesco. Rela-
tively few of the works ascribed to him are documented and none is
dated except the fresco of* Sigismondo Malatesta before St Sigismund
in S.Francesco, Rimini, of 1451.

*The Flagellation is painted on gesso ground on a poplar wood panel
(58.4 x 81.5 cm). It was probably painted between 1458 and
1466 possibly for a chapel in the Ducal Palace in Urbino. It is now in the
National Gallery of the Marches, Ducal Palace, Urbino.*

The Viking Press, Inc.

Piero della Francesca: The Flagellation

Marilyn Aronberg Lavin

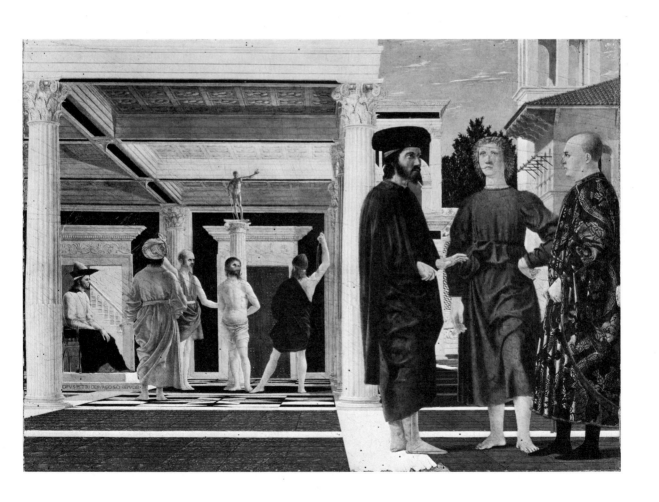

Published in 1972 by The Viking Press, Inc., 625 Madison Avenue, New York, N.Y. 10022
SBN *670-55494-4*
Library of Congress catalog card number: 74-165930
Filmset in Monophoto Ehrhardt by Oliver Burridge Filmsetting Ltd, Crawley, England
Color plate printed photogravure by D. H. Greaves Ltd, Scarborough, England
Printed and bound by Jarrolds, Norwich, England

Designed by Gerald Cinamon

Reference color plate at end of book

Preface

During my work on *The Flagellation* I received travel grants and financial support from the American Association of University Women, the American Philosophical Society, and the American Council of Learned Societies; to these institutions I am deeply grateful. Discussions with many colleagues and friends have greatly benefited my results. For specific contributions I wish to thank Professors Frank E. Brown, John Coolidge, Samuel Y. Edgerton, James Fasanelli, William Loerke, Elisabeth B. MacDougall, Charles Trinkhaus, and Rudolf Wittkower. To Professor Pasquale Rotondi and Dr Giovanni Urbani, I am especially beholden for their kindness in allowing me to study the painting at the Istituto Centrale del Restauro, Rome, under a variety of conditions and repeatedly over an eight-month period. Mr Thomas V. Czarnowski, Architect, who worked with me at the American Academy in Rome, drew the plans and reconstructions here presented. They are the outcome of a fruitful interchange in which Mr Czarnowski's interest and enthusiasm were vital factors. My greatest debt is to my husband, Professor Irving Lavin, who encouraged me to pursue this topic and whose ideas and observations in many instances stimulated my own. To him this book is devotedly dedicated.[1]

New York, October 1969

Historical Table

		1444
Rebuilding of San Francesco in Rimini (Tempio		1446
Malatesta) begun	Birth of Lorenzo de' Medici	1449
Roger van der Weyden in Italy		1450
Piero della Francesca's *Sigismondo Pandolfo Malatesta*		
before St Sigismund, signed and dated (Rimini)		1451
Lorenzo Ghiberti's *Porta del Paradiso*, Florence	Alberti completes *De re aedificatoria*	1452
Baptistery, completed		
Donatello completes Gattamelata monument, Padua	Gutenberg and Fust begin printing the 'Mazarin'	1453
	Bible at Mainz	
		1454
		1455
Façade of S. Maria Novella, Florence, begun according	Basinio Parmensis completes *Liber Isottaeus*	1456
to Alberti's design		
Palazzo Pitti, Florence, begun		1458
Piero della Francesca: *The Flagellation,*		
terminus post quem		
	Death of Giovanni Francesco Poggio Bracciolini	1459
	François Villon's *Testament* begun	1461
Buildings at Pienza for Pius II began by Rossellino		1462
Piero della Francesca's *Resurrection*, Borgo San		1463
Sepolcro, probably completed		
Paolo Uccello begins *Profanation of the Host* predella,	First printing press established in Italy at Subiaco	1465
Urbino		
Piero della Francesca's frescoes at Arezzo probably		
completed		1466
	Francesco Colonna completes *Hypnerotomachia Polifili*	1467
Laurana appointed chief architect at Urbino		1468
	Matteo Maria Boiardo completes *Canzonieri,*	1469
	dedicated to Antonia Caprara	
	Lorenzo Valla's *Elegantiae latinae linguae* published	1471
Leonardo da Vinci's name entered in 'Red Book of		1472
Painters'		
Mantegna completes Camera degli Sposi at Mantua	Marcilio Ficino finishes *Theologia Platonica*	1474

1. Introduction

Although Piero della Francesca's *Flagellation* is today one of the most famous and highly regarded paintings of the Italian fifteenth century, its prominence in the history of art is relatively new. Small in scale and housed in the out-of-the-way town of Urbino, its very existence is unrecorded before the late eighteenth century. When it made its first appearance in art historical literature some time after, Piero was, surprisingly enough, considered more a technician than an artist. He was remembered primarily as the author of three books in the field of theoretical mathematics and perspective, and *The Flagellation* was introduced as a minor work reflecting this interest.[2] Only around the turn of our century did the panel begin to be appreciated as a great work of art. With the waning of romantic attitudes and the critical acceptance of Post-Impressionism and Cubism, it was soon drawing praise for the very qualities that had earlier been censured: its restrained expression, purity of color and, above all, the perfect equilibrium of its organization. In 1911 the great Italian art historian Adolfo Venturi spoke of its form 'set jewel-like in the transparent air and silvery light'. By 1927 Roberto Longhi, who wrote the first full-scale monograph on Piero, was eulogizing its rhythmic intervals of solids and voids. By 1950 its lack of dramatic action, far from offending, inspired Bernard Berenson, America's long time taste-maker, to declare that of all Piero's paintings, *The Flagellation* was the one he loved best.

The painting's rise to fame during the generations attuned to abstract art is not surprising. The suppression of overt sentiment and apparent emphasis on formal values at the expense of the religious subject made it seem possible to find aesthetic fulfillment in the work without reference to its meaning. Aldous Huxley, for example, in the 1920s, and the Abstract Expressionist painter

Philip Guston in the 1960s, recorded this experience with enthusiasm and wonderment. 'The nominal subject of the picture recedes into the background,' wrote Huxley, 'we seem to have here nothing but an experiment in composition, but an experiment so strange and so startlingly successful that we do not regret the absence of dramatic significance and are entirely satisfied.' To Philip Guston the Flagellation scene was 'the only "disturbance" in the painting, but placed in the rear, as if in memory. . . . The picture is sliced almost in half, yet both parts act on each other, repel and attract, absorb and enlarge one another. At times there seems to be no structure at all. No direction. We can move spatially everywhere, as in life. Possibly it is not a "picture" that we see, but the presence of a necessary and generous law.'[3] Yet, historically speaking, there was no abstract art in the fifteenth century, and no painting without both a subject and a purpose. The factors that allow the twentieth-century viewer to read *The Flagellation* as 'non-objective' must, in its own time, have formed part of its meaning.

In relation to traditional art the composition is indeed eccentric. Nominally a Flagellation of Christ, it defies one of the most hallowed principles of Christian narrative illustration by relegating the biblical scene to a secondary position in space. In the foreground, where one would expect to find the main story, there are three imposing figures who at first glance have no apparent connection with the Passion scene. The oddity of these figures' prominence has always been recognized, at least implicitly, and there has been much speculation concerning their identity. When the painting first came to light, the three were thought of simply as consecutive fifteenth-century rulers of Urbino. By the early nineteenth century, the blond youth in the center was singled out as Oddantonio da Montefeltro, first duke of Urbino; the men at his sides were supposed to be his evil counselors, and the painting was interpreted as a memorial to the young duke's 1444 assassination, likened to the Flagellation. Although this interpretation was accepted widely, and is still maintained by many scholars as well as the local guides in

Urbino, it is demonstrably untenable.[4] And already by the end of the century other explanations were being proposed. Because of the 'oriental' appearance of the bearded foreground figure and the presumed mid fifteenth-century date, the subject of the panel was associated with the threat to Western Christendom of invasion by the Moslem forces that had conquered the Near East and taken Constantinople in 1453. Variations of the 'Turkish' theme were many during the first half of our century, all of which took the Flagellation image as a symbol of the Church in peril. The foreground group then was interpreted alternately as pagan plotters against, and Christian (Western and Byzantine) defenders of the Church. Perhaps the most important suggestion in the latter category was that of Kenneth Clark. Relating the panel to the Council of Mantua in 1459 (Pope Pius II's attempt to form an army to fight the Turks), Clark recognized the specificity of the portrait on the right of the group while pointing out the allegorical nature of the figure in the center. In a quite different vein, Ernst Gombrich proposed the Repentance of Judas as the subject of the foreground figures.[5]

Throughout all these discussions, aesthetic and iconographic, the pre-eminence of the scene's architectural setting was never lost sight of. There was even the suggestion, at one point, that it was the 'subject' of the picture – the perspective construction being an end in itself.[6] As the study of Renaissance perspective theory expanded, there also began a search for the construction's mathematical key. Clark again led the way: he sought the basic module through direct observation, and his efforts went far in describing internal harmonies and numerical relationships. But the major breakthrough was accomplished by Rudolf Wittkower and B. A. R. Carter when they treated the space of the painting as if it were real architecture. They discovered that Piero had done the same. Through a painstaking analysis, they reconstructed the plan and elevation of the foreground and the Judgement Hall [11]. For the first time, they revealed the true positions of the figures in relation to the archi-

tecture and the elaborate design of the marble floor pavement. Most important, they found in the process that while portraying three-dimensional reality with mathematical accuracy, Piero infused the construction itself with mathematical symbolism. Their study thus brought not only deeper understanding of the composition's inner workings, but established the painting as a prime expression of the theoretical and mystical thinking of the time. Recently, the system of construction was integrated with Piero's own theoretical writings, now viewed as among the greatest of his age.[7]

As much as these important studies increased our knowledge, they did not resolve the fundamental question raised by the painting, namely, what is the relationship between the way the composition is organized and the subject matter? Why is the Flagellation scene 'miniaturized' while a group of three figures is brought forward into prominence? Does the architectural setting, apart from its geometry, have meaning, and if so, what does it contribute to the subject as a whole?

In my effort to resolve these problems I make two assumptions: first that every element visible in the painting contributes to an overall message, and secondly that all the elements necessary for understanding the message are to be found within the painting itself. My method has been to follow all the indications Piero provided, general and specific, as far as they lead. In so doing, I have come to certain conclusions I believe are valid. I emphasize that my findings are, and probably will remain, hypothetical. There are no known documents concerning *The Flagellation*, and therefore no external proofs. But I have found a coherent relationship between the organization of the composition and the subject matter which establishes the painting as an integral work of art. Once the form and content are seen to be working together as a harmonious unit, its various parts can no longer be dealt with in isolation. Any counter-proposal to my hypothesis will have to present an equally complete system of meaning, equally responsive to the painting's internal demands.[8]

2. Physical History of the Painting

The Flagellation was first noticed in the 'old sacristy' of the Cathedral of Urbino when an inventory of surviving paintings was made in the late eighteenth century after the vaults of the church had collapsed. It is likely that the original frame was then still in place. In 1839 the German art historian Passavant records having seen a Latin phrase *convenerunt in unum* (Psalm ii, 2) nearby the figures in the foreground. Crowe and Cavalcaselle say, however, that when they inspected the painting before 1864, 'the motto had somehow disappeared'.[9] There is one inscription on the painted surface, namely the artist's signature, but there is no trace of any other. The strongest possibility, therefore, is that the biblical words were painted on or attached in some manner to the frame. When the frame was lost, the inscription disappeared with it.

Notwithstanding this loss, the painted surface itself has demonstrably retained its original dimensions. The panel, made of the usual poplar wood, includes blank areas (previously covered by the frame) on all four sides of the painted scene. As was customary, the frame had been built on to the panel before painting began, and the entire surface, including the frame, given a gesso base. A low ridge of plaster formed in the tiny space between the flat surface and the inside edge of the frame. Except for a few chinks, this collar is intact around the perimeter of the painted scene [1].

There have been various losses of paint within the scene, especially in the faces of Pilate and two of the foreground figures. A deep plume-shaped gouge destroyed a considerable area around the face of the flagellator to the left of Christ. Late in the nineteenth century dovetailed wedges of wood were set into the back of the panel in an effort to straighten out warping. These inserts had disastrous effects; the counterpressure they exerted caused three long

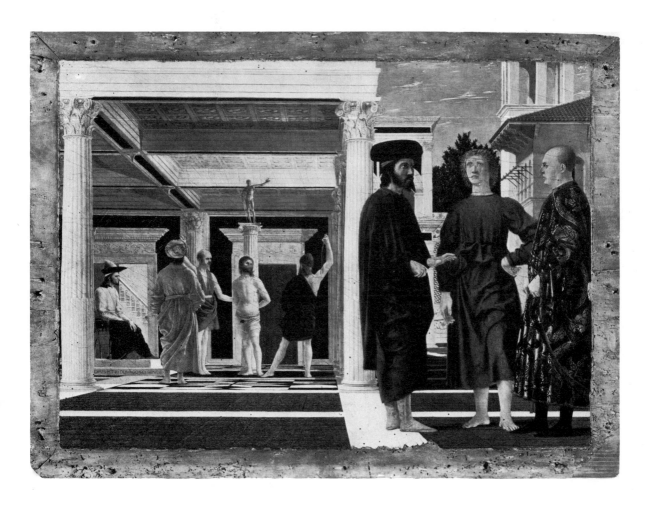

1. *The Flagellation*,
Piero della Francesca
(after restoration 1969)

cracks that run the width of the panel, passing through all the figures and splitting the face of Christ in two.

In 1951–2, the painting was taken to Rome for treatment at the Istituto Centrale del Restauro. The supports of the panel were rebuilt; layers of yellowed varnish and overpaint were removed; and

the three cracks were 'in-painted'. The picture was X-rayed and a series of new photographs was taken. Many previously hidden visual effects were revealed by this cleaning campaign, and in fact the observations in this study concerning light and space and the significance of both, were made on the basis of the new evidence [2].[10]

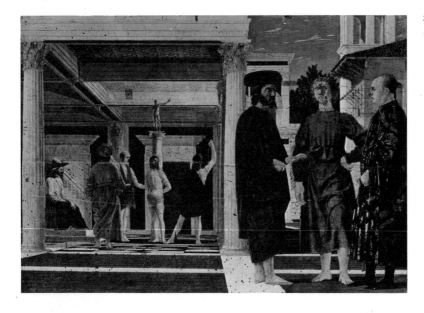

2. *The Flagellation*, Piero della Francesca (after restoration 1952)

During the years since 1952, unfortunately, the in-painting began to lift from the surface. The painting was taken back to Rome in 1968 for repair and further restoration. Work was completed in the spring of 1969 and a scientific report will be published in the near future. The new results are startling. The freshness and limpidity, so much admired before, are now multiplied tenfold. More details have reappeared. These involve a number of razor-thin shadows that crisscross the floor of the Praetorium and lie by the cusps on the roof beams above Pilate's throne. These newly-found shadows, incidentally, all conform to the reconstruction of light flow made here. Beyond these direct shadows, there are now visible exquisite areas of reflected light and secondary shadows, notably on the feet

of the profile foreground figure. Actual under-drawing is visible in several areas, as on the ceiling rosettes and especially in the right hand of the blond foreground figure, thought previously to be a ruin. This drawing is seen easily in photographs. Many of the long knife-shaped shadows are so subtle and delicate, however, that they remain all but invisible to the camera's eye.

Probably the most spectacular result of this second campaign, made in the last months of work, was the discovery and restoration of the lost part of the face of the flagellator to the left of Christ. Part of his nose, cheek, mouth and chin were found crammed in the depth of the gouge. This tiny fragment, no more than a few millimeters across, was extracted, straightened, and reset in place, making the expression of the face once more readable. This detail appears in color and full-scale on our jacket.

Long before the face was recovered, I had chosen this detail for the jacket for a different reason. I wish to show the turban of the figure with his back turned. A miracle of color, light and interwoven forms, the turban has on its edges the traces of 'pouncing', a technique for transferring a design from a previously prepared paper cartoon to the painting surface by pricking the cartoon with pins and patting charcoal dust through the holes. Piero here used a minuscule cartoon for the turban alone, allowing the many points that guided his brush to show in the final execution. This technique, used frequently by Piero in his large-scale frescoes, is not found elsewhere in this painting. Guidelines drawn with a metal point in the gesso can be seen in some of the architecture.

It was a happy conjunction of events that brought this monograph into being just after the new restoration campaign. Our photographs were taken when the work was complete but before the painting received its new display-case and protective glass cover. These photographs, color and black and white, thus give an impression of *The Flagellation* closer to its original appearance than any previously available. The painting is regularly on display in the National Gallery of the Marches, Ducal Palace, Urbino.

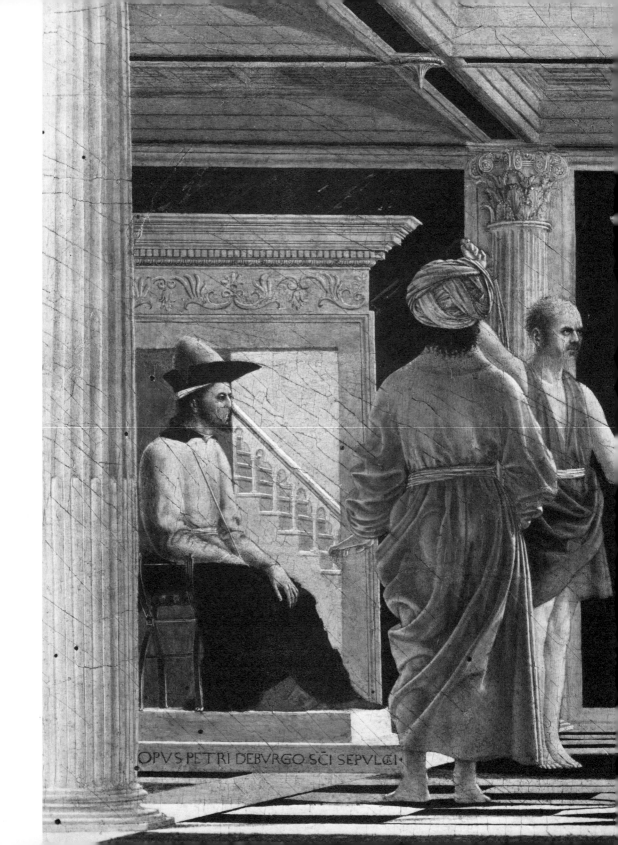

OPVS PETRI DEBVRGO SCI SEPVLCRI

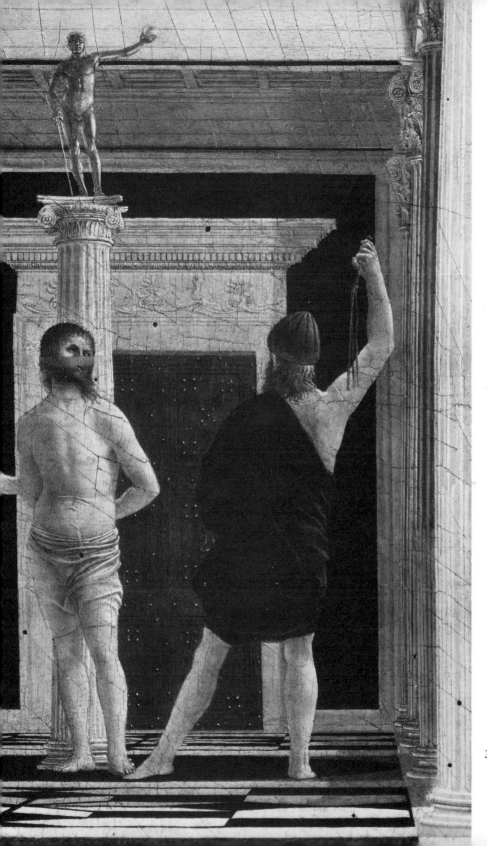

3. *The Flagellation*, detail of 1

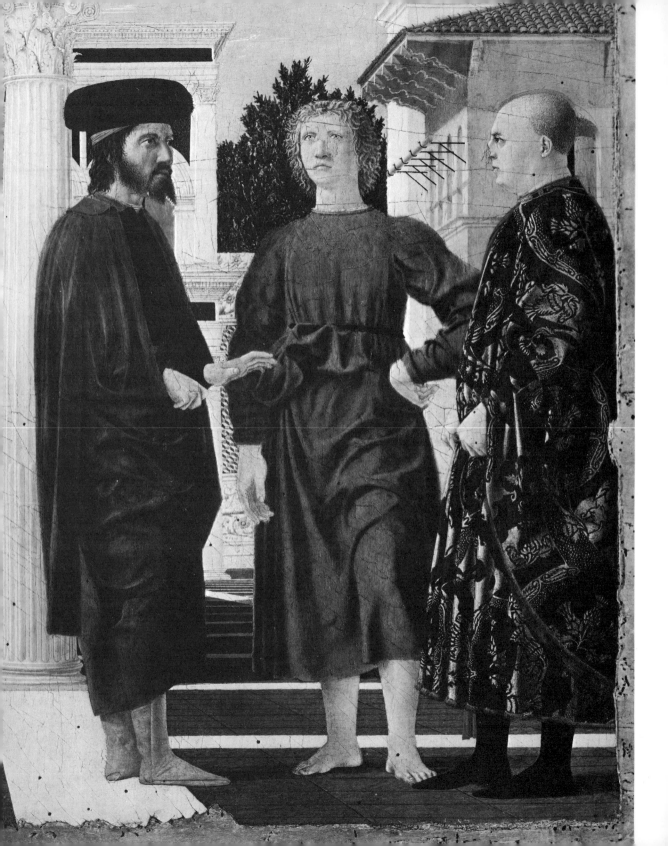

3. The Sources of the Composition

The first impression made by *The Flagellation* is of a vast and unified urban area containing two distinct groups of figures, three out-of-doors in the foreground, and five within the architecture in the middle distance [1]. The distant group is recognizable as a scene of the Flagellation of Christ from the haloed figure tied to a column between two whip-wielding men [3]. Pilate, the judge, is seated on his throne. The foreground group recalls by its presence the Jews and Pharisees commonly shown in narrative representations of the scene [4]. These figures are, however, more prominent than usual and oddly distant from the scene they might be witnessing. Turning their backs on the Flagellation, they are distinct from it in a psychological as well as a physical sense.

At the same time, despite this separation, we are equally struck by the way the two groups relate to one another visually. The triad in the foreground is repeated by Christ and his flagellators. Both central figures, considerably paler in color than their companions, stand with their weight on the right leg, left arm bent at the elbow. Both are emphasized by features over their heads, the statue on the column above Christ, a tree and open sky above the young man. The mute stare of the man in profile at the right foreground is echoed at the left by Pilate's fixed gaze. The three-quarter view pose and the hand gesture of the bearded man in the foreground is echoed by the combined poses of the left-hand flagellator and the turbaned figure with his back turned under the portico. This turbaned figure, moreover, has the same relationship to the Flagellation scene, as we, the spectators, have to the painting itself, and particularly to the group at the right. The same kind of visual reciprocity may be observed in the arrangement of colors and linear patterns. These clear and deliberate formal analogies establish an intense interplay

4. *The Flagellation*, detail of 1

between the forward and distant groups. We shall see that both these impressions, of separation and of identification, are significant elements in the expression of the painting's meaning.

Seen in an historical context, the most striking fact about the design is the radical way it differs from contemporary representations of the Flagellation. The actual date of Piero's painting is not known and opinions on it differ substantially, ranging from about 1445, where it would figure as one his earliest works, to as late as 1472. We may take as a working hypothesis a date of the mid fifteenth century, and compare the composition with other major Tuscan

5 *(left)*. *The Flagellation*, 1417-24. Lorenzo Ghiberti

6 *(right)*. *The Flagellation*, Sienese School, 15th century

examples. Lorenzo Ghiberti, Andrea del Castagno, a mid fifteenth-century Sienese artist, and others, all represented the Flagellation with the Judgement Hall, or Praetorium of Pilate, in the form of a colonnaded portico, in the center of the scene [5 and 6]. The figure of Christ, manacled to a column, is in the center of the architecture and a number of figures are arranged in balanced groups on either side.[11] All these compositions are thus centralized and symmetrical. Piero too depicted the Praetorium as an open loggia. But he deprived it of its central position, placing it far to the left. At the right, he introduced an area of space open to the sky. The surprising aspect

of his departure is the fact that it seems deliberately to revive a formal type invented in the early fourteenth century and out of fashion for nearly a hundred years.[12]

An important example of the asymmetrical form is a fresco on the vault of the transept of the Lower Church of San Francesco in Assisi, painted by the school of Pietro Lorenzetti about 1325 [7].

The Praetorium, an airy portico lavishly encrusted with inlays and carvings, is placed off-axis to the left. Raised on a two-step platform, its main space is a two-bay hall which is extended at the right to form a small covered area peopled with Jews and soldiers. Christ is tied to a column in the center of the portico and Pilate is enthroned at the left between two military counselors. Outside the building, in the corner formed by the parapet wall, is a plot of ground planted with flowers. Piero's composition is obviously related to this type of arrangement. However, it is probable that he did not follow the Assisi fresco alone, but also drew on a more modest version of the same formula in his native town of Borgo San Sepolcro with which he must have been familiar for most of his life. This asymmetrical

7 *(left). The Flagellation, c.* 1325. School of Pietro Lorenzetti

8 *(right). The Flagellation,* Sienese School, 14th century

Flagellation appears on the predella of a mid fourteenth-century altarpiece, formerly in the church of Santa Chiara in Borgo, today on the high altar of the Cathedral [8]. In a reduced and simplified form, the little panel follows the configuration of the Assisi fresco: the Praetorium is again off-center to the left, and a plot of open ground fills the space outside the building to the right.[13]

Piero took up the basic arrangement of these fourteenth-century works, adopting many of their details as well. His colonnaded Praetorium similarly dominates the lateral dimension of the picture plane, covering nearly two thirds the width from the left of the panel. Christ, his body unbruised, is again placed against a column deep within the building. The flagellator to the right bears a marked relation to the same figure in the Assisi fresco; he is seen from the back poised for a downward stroke with his whip. Piero has raised the right arm higher. His partner touches Christ's right arm with his left hand, as in the Assisi fresco, although the left arm is raised up somewhat like that of his counterpart in the San Sepolcro predella. Pilate in all three versions is enthroned at the left. The turbaned counselor, who in the San Sepolcro predella stands at Pilate's right is retained by Piero. He is moved out into the loggia, his back to the spectator, but he still grasps his garment with his right hand. As in the predella, the back of Piero's portico is pierced by openings. The ceiling is coffered, and like both the predella and the fresco, the floor is paved with polychrome geometric marble inlay. There is a two-storied construction to the right and behind the portico proper, alluding to the rest of Pilate's palace, as in both earlier examples. And Piero's open piazza is, basically, an amplification of the plots of exterior space in the right-hand corners of the same works.

There thus can be no doubt that Piero had the old pictorial tradition in mind when he began to organize his composition. And yet, we must reckon with the fact that while adhering to the asymmetrical arrangement of his prototypes, he radically altered the relationships in depth. In both the Assisi fresco and the San Sepolcro predella, the Praetorium coincides with the picture plane. The figures in both are in more or less frieze-like arrangements distributed laterally across the scene. Piero set his Praetorium far behind the picture plane and projected the area of exterior space both forward and deeply behind it. He introduced a second range of buildings at the right, and opened a vista of landscape and sky above a wall in the far background. By placing one group of figures in the foreground, and

9. *The Flagellation*, Pisan School, 14th century

another considerably farther back, he broke the continuity of the traditional narrative. He thereby distinguished the figures in the foreground from the ancillary characters that populate the sides of earlier scenes.

It must have been the desire to achieve this effect that led Piero to reject the symmetrical type of Flagellation current in his own time. The centrally placed Praetorium in a rationally continuous space, whether near the picture plane or deep behind it, ordinarily imposes a single focus of time and place on all elements of the composition. I know of one remarkable exception to this statement, where a centralized composition succeeds in giving the impression of two distinct realms: *The Flagellation* [9] on one side of a late fourteenth-century panel of the Pisan School. Here the Flagellation is housed in a little building that comes to an abrupt stop at the front in a V-shaped, molded step. Outside in front of the building, at either side, are two saintly bishops. The one at the right directs the attention of four members of a flagellant confraternity to the biblical scene. Through ingenious devices of scale, gesture, and framing motifs, the image breaks spatial and temporal continuity, and represents the devotional exemplar of the confraternity.[14] The Pisan panel thus forms a precedent for Piero's idea (see below, p. 48). However, our artist chose the asymmetrical format and through it created a rationally unified image with an unobstructed view of the Flagellation, and a separate area of space in which other elements exist independently.

4. The Setting

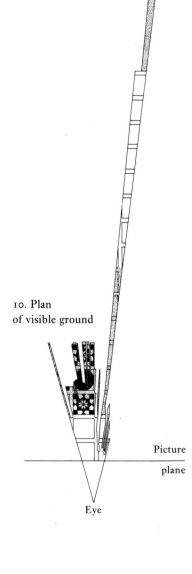

10. Plan of visible ground

Picture plane

Eye

Although infinitely clear and lucid, stable and monumental, the lay-out of the setting is not immediately apparent. A number of vertical members (figures and architecture) cover most of the ground surface, reducing what is visible to a fraction of what must actually be accounted for. A plan of the visible ground surface is shown in [10]. The clues that Piero provides are thus minimal. We shall find, how-ever, that they are sufficient to render the environment rationally comprehensible. That he gave us clues at all, moreover, is a sure indication that he meant them to be pursued. The main points to observe are: 1. the regularity of pattern in the pavement decoration, 2. the uninterrupted view into space (between the center and left-hand figures of the foreground group in illustration 4), and 3. the areas on the ground that are differentiated by light and shadow.

The ground surface outside the Praetorium loggia is paved with small terracotta-colored tiles, and these tiles are set in large squares, eight tiles wide and eight tiles deep. Each large square is surrounded by unbroken white paving strips. These square units designate the pattern for the whole piazza and can be counted for many ranges as they recede into the distance. There are two pavement units in front of the Praetorium, the first of which, where the foreground figures stand, being incomplete where it meets the picture plane. Under the roof of the portico are three units, each decorated differently but corresponding in size to one of the large red squares; the colonnade lies on a white paving strip. The front and back bay of the portico have a pattern in porphyry red and white of a central eight-pointed star surrounded by squares and other geometric shapes. The tur-baned figure stands in the front bay. The central bay, in the center of which is Christ at the column, is decorated with a perfect circle of serpentine green, with pink-colored spandrels. Because of the sharp

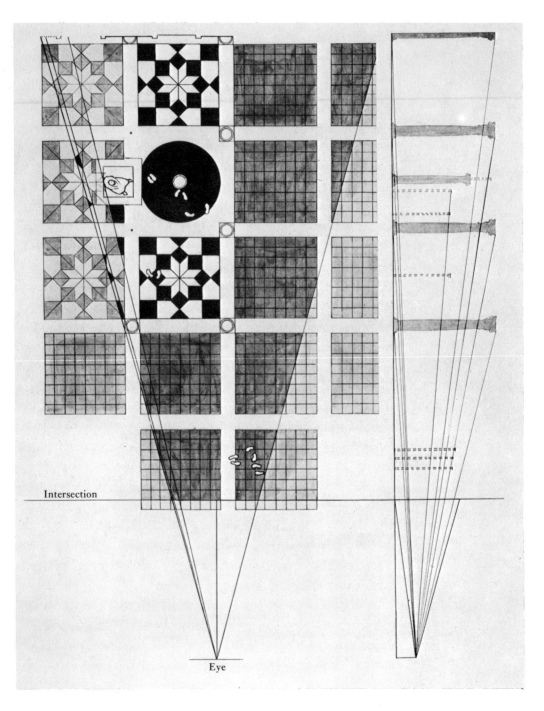

Intersection

Eye

perspective in which these patterns are shown, they remain disguised until reconstructed technically [11].[15] The loggia proper ends in a wall pierced by two doors, one closed and one half open on to a view of a stairway.

The foreground of the painting is in bright sunlight. This light is part of a consistent flow that enters the scene from the left at a very steep angle. The angle is measurable at twenty-six degrees, and can be seen clearly in the slanting shadow on the interior of the tower at

11 *(left)*. Reconstruction: plan and elevation (from Wittkower and Carter)

12. *Perspective of inlaid pavement*, Piero della Francesca

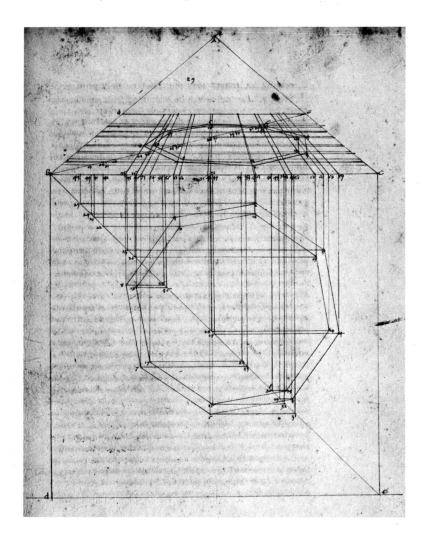

the right. The light flow causes the first column on the left and the three foreground figures to cast long, thin shadows on the ground to the right. A larger shadow cast by the Praetorium itself may be observed behind the figures, where the red tiles are darker red, and the white strips are gray. Counting along the shadowed transverse paving strips, we find this darkened area to be six units deep. Since the portico is only three units deep, the three extra shadowed units indicate additional structure behind the loggia wall.

After the eighth unit the piazza is once more flooded with light. Tracing again the white strips, we find this lighted area to be a full eight units deep. Only with this observation does it become evident that the partially visible two-story marble-encrusted structure projecting to the right of the Praetorium is a second, independent edifice of grand proportions. This building too casts a shadow on the pavement, accounting for a second change to darker color in the far background. The perspective diminution at this point has become so acute that the pavement pattern can no longer be seen. Only the transverse strips in their shadowed color of gray are represented. That so much ground surface can be seen at such a distance, assures us that it is very long indeed. By mathematical calculation it can be reconstructed as covering almost ten units. The shadow stops before reaching the wall that closes the piazza, which is in full sunlight. Totalling the number of units between the picture plane and the wall and converting the sum into natural size, the piazza measures about 250 feet [13].[16]

Having completed the ground plan, we now turn to the elevation of the buildings which are articulated in great detail. When discussing the sources of the composition we saw that in depicting Pilate's Praetorium as a colonnaded portico, Piero was following a widely used convention for the form of the Judgement Hall. But never before had the building been portrayed in such magnificent classical style [1 and 3]. The gleaming colonnade is of corinthian order with simple frieze. The interior walls are revetted with porphyry and other rich marbles, the jambs and cornices elaborately carved, the coffers

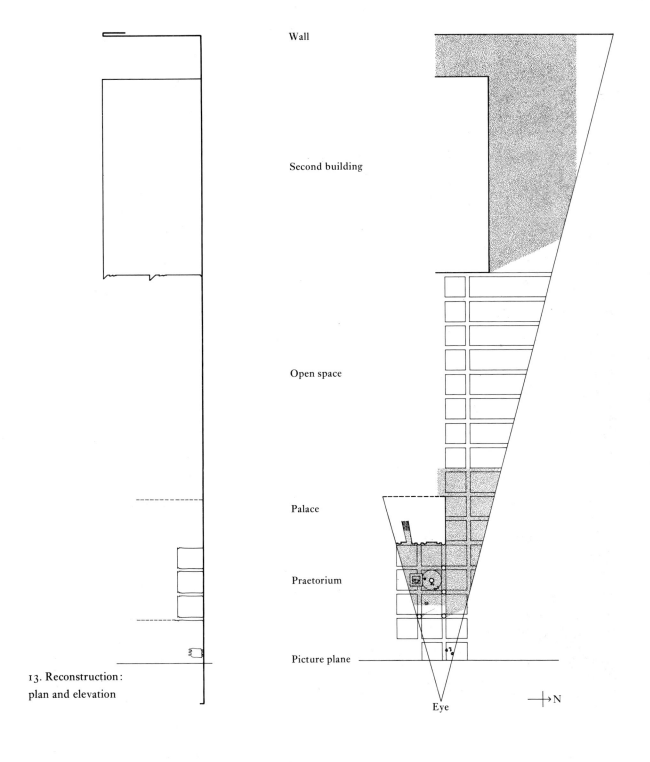

Wall

Second building

Open space

Palace

Praetorium

Picture plane

13. Reconstruction:
plan and elevation

Eye

→ N

36

decorated with large rosettes. All these elements are stunning representations of architectural motifs currently being revived and developed for real architecture. They reflect the verbal descriptions and prefigure some of the actual buildings of the noted architect and theoretician Leon Battista Alberti with whom Piero had contact in Rimini in the early 1450s.[17] The brilliance and finish of Piero's Praetorium, in fact, is often compared specifically with Alberti's Rucellai chapel in San Pancrazio, Florence, and the family tomb it houses [14 and 15].

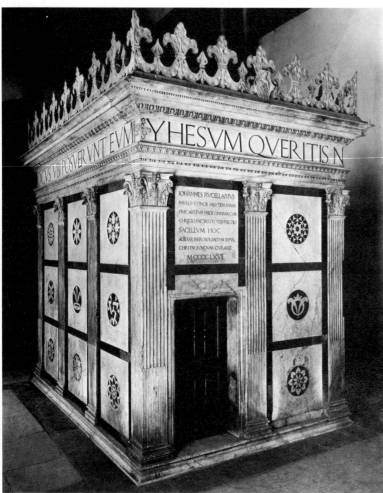

14. San Sepolcro Rucellai, Florence, 1457–67. Alberti

What has not been pointed out is that the relationship between the two structures has an even deeper level of significance. Piero's use of one particular detail from the Cappella Rucellai makes his reference unmistakable. The shafts of the painted corinthian columns have filled fluting in their lower half; the same is true of the shafts of Alberti's free-standing columns (originally the entrance to the chapel, but moved with their trabeation to the outer façade of the church in 1808). This column-shaft form is unique in the work of Alberti; it does not appear in any other example of Piero's painted architecture.

15. Cappella Rucellai, Florence, 1457-67. Alberti

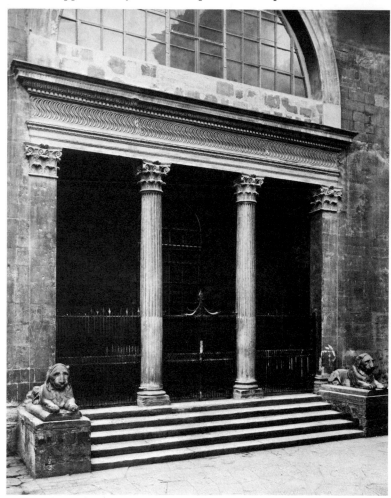

Piero's columns may therefore be considered a direct quotation, in the manner of one author quoting verbatim from the text of another, and naming his source. Recent scholarship dates Alberti's work on the Rucellai commission as in the designing stage in 1457. It is more than probable, considering their personal acquaintance, that Piero was able to see plans and drawings of the chapel while they were in preparation.[18]

On such an occasion, Piero could have been made aware, moreover, of a singular fact regarding Alberti's project. The Rucellai tomb housed in the chapel [14], a small free-standing, roofed chamber, was to be made in imitation of the tomb of Christ in the Church of the Holy Sepulchre in Jerusalem. Giovanni da Paolo Rucellai, Alberti's patron, himself recorded that he sent an expedition of engineers all the way to the Holy Land to document 'the correct design and measurements' of the San Sepolcro for this very purpose. The Rucellai tomb was thus thought of as an ideological if not an archaeological reconstruction with specific symbolic meaning. And in fact, it has always been called the 'San Sepolcro Rucellai'.[19]

When we ask what this information might have meant to the painter of *The Flagellation*, we begin to get an insight into the meaning of Piero's quotation. The House of Pilate, like the Holy Sepulchre, was one of the pilgrimage shrines of Jerusalem. Recorded from the fifth century onward as a place of veneration, it entered history as a ruin, and during the Middle Ages was reported in three different geographical locations. By the Renaissance, we know from various sources, it was thought to have been in the ancient Fortress Antonia, in the north-east section of the city. This area, including a chapel of the Flagellation, during most of the fifteenth century was occupied by the palace of the Moslem ruler of the city, and Christians were forbidden entrance.[20] We cannot posit, therefore, a delegation making drawings and measurements of Pilate's House, as had been done of the Holy Sepulchre, that might have been shown to Piero.

There exists, however, a contemporary Italian literary source that records what any pilgrim who journeyed to Jerusalem would have

16. *The Flagellation*, detail of 1

learned about the site. This source is an unpublished manuscript in the Vatican Library in Rome, called 'Viaggio di Gerusalemme', written for a gentleman of Rimini by a certain Andrea. The author describes in detail his journey to the Holy Land which took place between 20 September 1457 and 24 April 1458.[21] Andrea's chapter on the House of Pilate is mostly a compilation of elements from various literary traditions describing the biblical events that took place there.[22] About the architecture directly, since he was unable to enter the precinct, he has almost nothing to say. Yet his text sheds light on some of the contemporary notions concerning the physical make-up of the biblical Praetorium.

The chapter is called 'Dov'è eranno le case di Pilato' (Where the houses of Pilate were). The plural form 'le case' suggests a tradition for more than one building. As we have seen, when discussing the plan, the architecture on the left side of Piero's painting consists of not one building but a complex including an edifice with Praetorium, an open court, and a second large building. The arrangement may justly be called 'le case di Pilato'. The 'Viaggio' text describes a stairway, under which Christ was imprisoned and mocked, and at the top of which was Pilate's throne. Piero made a special point of representing a stairway in direct relationship to Pilate's throne by opening the view through the doorway in the back wall of the Praetorium [16]. These steps, moreover, are probably a reference to the Scala Santa, the venerable relic near San Giovanni in Laterano in Rome, believed since the eighth century to have been transported to Rome by St Helen from Pilate's house. The actual flight in Rome is composed of twenty-eight marble steps. The view through the door in the painting invites us to complete the flight in our minds as something near that number.[23]

The text of the 'Viaggio' gives no hint as to what the rest of Pilate's palace was like. Piero, on the other hand, indicates that he may have information from other sources. His distant building [17] can be generally described from the portions that appear behind the bearded foreground figure. It rises to a height of some forty feet.[24]

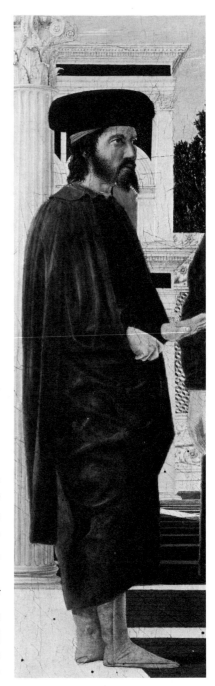

17 *(left)*. *The Flagellation*, detail of 1

18. Loggia Rucellai, Florence, *c.* 1460. Alberti

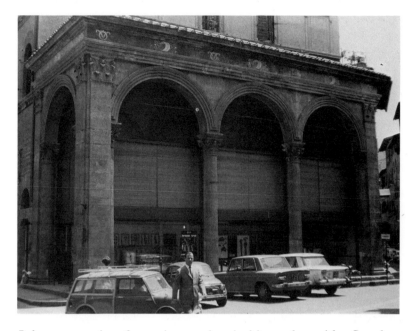

It has two stories of superimposed corinthian orders with a flat, that is, not vaulted, roof. Whether the ground floor is open or closed cannot be judged since only the corner pilaster can be seen. But the upper story is composed of a series of arched openings. Because the one that is visible is furnished with a tan-colored wooden shutter (note the small opening at the neck of the bearded figure, illustrations 17, 33), it is probably a window with an arched top. The springing points of the arches between the windows meet on a common impost block, creating a peculiar arrangement in which there is no intervening wall space. This detail is seen behind the nape of the bearded figure's neck. The walls above are revetted with colored marbles. Stylistically these arches, with their concentric moldings, call to mind the arches of the Loggia Rucellai [18] where similar moldings dovetail (but join horizontally) over the impost block of each column. The corner pilasters of both stories of Piero's building are similar to the corinthian pilasters on the San Sepolcro Rucellai [14], and, in the proportional relationship to the arched windows they frame, are close to the windows on the façade of the Rucellai palace

19. Palazzo Rucellai, Florence, 1446-51. Alberti

[19]. Notwithstanding these similarities, the shape of Piero's building is unlike anything in the Rucellai complex. Nor can any classical prototype among two-storied basilicas or monumental gates, for example, be cited.

I have found, however, one analogy which is very close, and it is another representation of Pilate's house. There is in the Vatican Library a splendid illuminated manuscript Latin translation of the

20. *Topographical view of Jerusalem,*
from a manuscript of 1472

Cosmographia of the ancient Greek scientist Ptolemy. Dated 1472
and made for Federico da Montefeltro, future patron of Piero della
Francesca, this manuscript contains many illustrations of famous
cities and sites throughout the world. One is a topographical view of
Jerusalem [20]. Near the Gate of St Steven we find Pilate's palace
(inscribed 'P[alatio]. Pilati' [21]). Here the palace is represented as a
rectangular, flat-roofed structure, two stories high, the lower closed

21. *House of Pilate*, detail of 20

and the upper pierced by a continuous sequence of arched windows. In other words, it is similar to Piero's structure. Considering its date and provenance, the manuscript illumination could well be a reflection of Piero's building. More probably, however, they both rely on a common source that is otherwise unknown.[25]

The piazza outside Piero's Praetorium also has historical precedent, both for its vast size and its rectilinear pavement. Not only is it mentioned in the 1457–8 'Viaggio' but it is cited and named in the Bible. St John the Evangelist (John lxix, 13) calls the place where Pilate came forth to pass judgement on Christ the *Lithostratos*, meaning the Pavement. In modern times a court near the Fortress Antonia was excavated and found to measure about 130 x 95 feet, and to be paved with heavy stone blocks, rectangular in shape.

Besides the *Domus pilati*, the pilgrim Andrea describes in his text two other important relics of the Flagellation in Jerusalem. These were housed in the Church of the Holy Sepulchre. One was a piece of the Flagellation column, to be seen in the chapel of *Noli me tangere*. The other was a depression in the ground beneath the altar in another chapel, said to have been made by Christ's feet while he

was being beaten. The latter chapel, says the pilgrim, was called 'the place where Christ was imprisoned'; but since it duplicates the place in Pilate's house, he doubts the truth of the identification.[26] In any case, the importance of these notices is that they demonstrate that relics of the Flagellation were in the Church of the Holy Sepulchre and that the House of Pilate and the Sepulchre of Christ were specifically linked in the lore of the Holy Land.

It may be that in this association Piero found personal significance for himself. According to tradition, his native town of Borgo San Sepolcro was so named because of relics from the Holy Sepulchre brought to Tuscany by two pilgrims in A.D. 934. The town developed around the oratory built to house the venerable objects.[27] It was perhaps for this reason that Piero signed himself with the full name of his native town OPUS PETRI DEBURGO SCÍ SEPULCI so conspicuously on the base of Pilate's throne [16].

But beyond this personal reference, the relationship between the Flagellation and the Church of the Holy Sepulchre reveals the significance of Piero's quotation from the Rucellai chapel. Lacking exact knowledge of the architecture of the biblical Praetorium, but desiring to get as close as possible to the prototype in Jerusalem, Piero employed the style and specific motifs from Alberti's Rucellai chapel, whose connections with the Holy Sepulchre (and hence with the Flagellation), were common knowledge. In this way he proclaimed the archaeological significance of his setting and, like Alberti, re-created a holy shrine in modern ecclesiastical style. The exquisite realism in the rendering of the architecture should be understood as expressing the topographical veracity of Pilate's house.

But at the very moment we are convinced of the Praetorium's reality, we discover that Piero's intention is even larger. By a series of interrelated effects he shows us that the Praetorium exists, not in our world, but in another realm.

Looking into the ceiling of the Praetorium, we notice that while the first and third bays are in shadow, the bay in the center is ablaze

with light. Being the ceiling over Christ, the 'Light of the World', we associate it with his presence. The light, however, does not emanate from Christ; the halo of golden rays that surrounds his head has brilliance but in a literal sense does not shed light. Next we notice that all the vertical forms in the Praetorium, including Christ, the statue above him, the front of Pilate's dais, even the studs on the door in the back, are highlighted on their right sides. Highlights on the right are in direct opposition to that which obtains outside in the piazza where, as we have seen, the forms are lit from the left. Demonstrative of this reversal are the bright edges of drapery on the left side of the blond boy in the foreground and on the right side of the turbaned figure under the portico. We must conclude, therefore, that the light in the Praetorium ceiling is part of a consistent flow that comes from a second, independent source.

Scrutinizing the colonnade now very closely [3], we find evidence to bear out this conclusion. The colonnade has the following sequence: The first column is in light coming from the left. The second column is dark, as is the soffit of the intercolumniation (a tiny section of which is visible with its dark marble veneer behind the first capital). The third column is in bright light, and so is the soffit of the second intercolumniation. The fourth column is dark. To have this sequence, a light must enter the Praetorium from somewhere between the second and third columns.

The fact is that Piero arranged the light as though beaming from one exact spot, and he treated the flow with such consistent logic that we are able to reconstruct the location of the source. The shadows cast by the architectural members inside the Praetorium are measurable and by measuring three of the clearest (that on the right side of the coffers in the first bay, that in the left back corner of the same bay, and that on the ceiling over Pilate's head), we can reconstruct the planes their surfaces define. Illustration 22 is a representation of these planes, numbered I, II, and III. The point where these planes intersect locates the source of light. The position of this point in space is shown in our axonometric view [23]. It is a

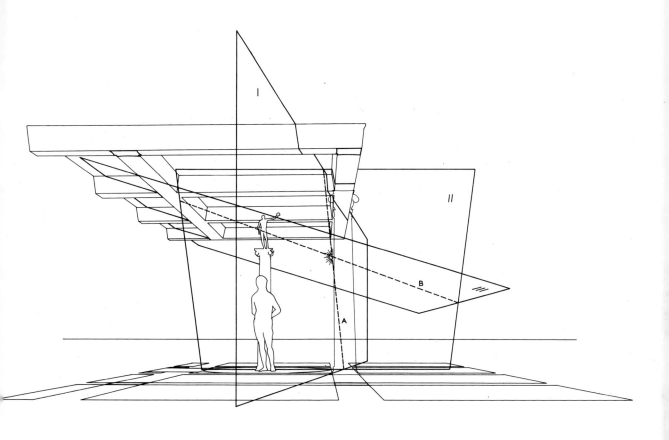

22. Secondary light source

short distance behind the second column, slightly within the inter-columniation at the height of about two thirds a column. The closest object to the source would be the arm of the right-hand flagellator. Indeed, his raised arm is one of the brightest spots in the painting.

Locating the source is an important step in understanding the significance of the secondary light flow. Assuming the outside light in the piazza to be the light of our world, that is the northern hemi-sphere, then its flow from left to right at a steep angle (twenty-six degrees) indicates that left in the painting is toward south and right is toward north. The light in the Praetorium coming from the right, that is north, is therefore specifically not of our world. Piero has used a totally rational construction to make an unnatural phenom-enon look as realistic as possible. By this mystical effect he marked the Praetorium as a divine sanctuary, and the biblical event taking place within it as a miraculous apparition.[28]

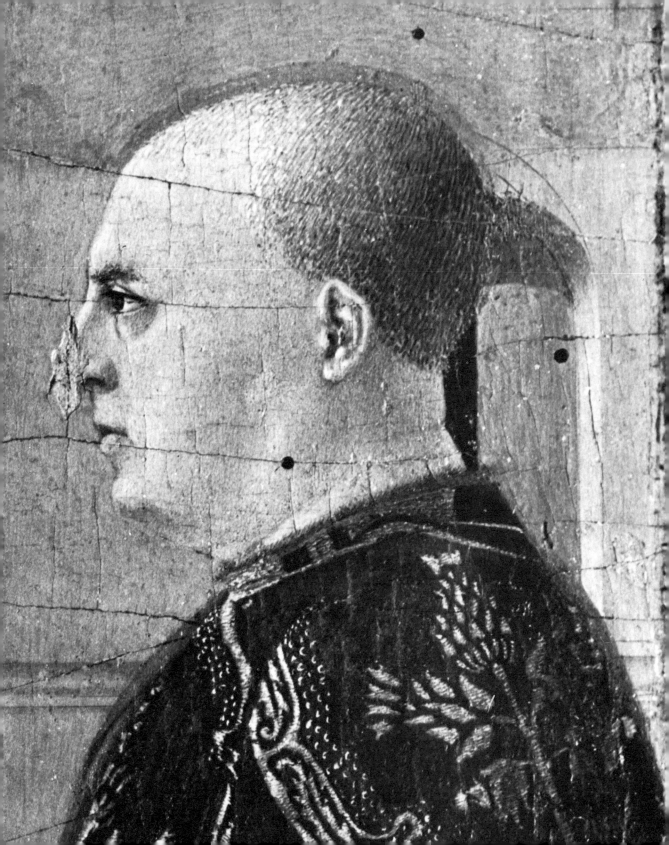

We now turn to the buildings on the right side of the piazza. While forming major constituents in the overall perspective scheme, these buildings have completely different elements of style and construction from those observed in the building of Pilate's house. The two structures, one a palace of pink stone with a tile roof, the other a lofty white tower pierced at the top, are pointedly not Albertian in style. The palace is a typical fifteenth-century aristocratic domestic dwelling, not marble encrusted, nor decorated with classical motifs. I can offer no historical precedent for the structure of the tower. Moreover, these buildings cannot be located on the plan. Their ground lines are totally masked by the bodies of the foreground figures. X-rays of the painting show no architectural drawing under these figures. Without knowing where they are in depth, it is impossible to judge precisely how tall they are. This is true in spite of the fact that Piero is not stingy with details: he shows how many windows there are in the façade of the palace (four), the number of brackets supporting the roof-overhang, and the distance between the brackets on the side of the building. The one indication that is of some help in judging scale is the window partially visible behind the man in profile [24]. This opening, like the one on the second edifice of Pilate's house, has a wooden shutter standing ajar. The diameter of the arched top of the window opening looks quite close in size to the aperture across the piazza. The two buildings also look rather similar in height. We might therefore assume that the pink palace is somewhere near the same location in depth, but precisely where remains unknown. The tower is unmeasurable for several reasons. Whereas we can see that it is behind the domestic palace, we cannot judge its location relative to the wall. Since neither its bottom nor its top extremity is visible, we can surmise only that it is, literally, very tall.

A genuine polarity thus exists between the two sides of the piazza, and this polarity functions to differentiate them as two separate realms. The buildings on the left represent a divine world with supernatural attributes, structured with immutable values. The

buildings on the right represent the real world, unpredictable and incomplete, its values shifting, its order elusive and masked.

The long open space that separates these two realms has multiple connotations. It alludes to the *Lithostratos* because of its form and proximity to the Praetorium. It functions equally well in relation to the worldly buildings as the public piazza in a Renaissance town. Piero closed this space with a wall. From its position in the perspective construction, the height of the wall can be computed at slightly under forty feet. It is made of white marble and decorated with colored *rinceau* patterns at the top and bottom, with the large central section covered by a perspectivized geometric inlay pattern. As an architectural agent it is neutral. Of neither one style nor the other, neither ecclesiastic nor domestic, it forms a physical limit to the organized space and a formal link between the two worlds. Behind the wall there is more space *en plein air*, unmeasurable but vast, where a spreading tree rises to formidable heights.

With the full layout of the composition at our disposal, we may inquire into what is perhaps its most remarkable aspect. The foreground figures stand in a kind of spatial no-man's-land, with no architecture in their immediate vicinity. And yet, they *look* as though they are directly juxtaposed to the background elements and are visually wedded to them. Although all three figures, in reality, are in front of the second building of Pilate's house, because of the spreading of the visual cone, each figure appears before a different side of the piazza: the man in cut-velvet before the civic mansion, the blond youth before the wall and the tree, and the bearded gentleman before the buildings of Pilate's house. Each side of the piazza, reduced by its position in depth to the size of a frame, forms an individual backdrop. Having its own 'personality', each backdrop acts as a foil and character witness for the figure standing before it. Here is explained the extreme depth of the projection as well as the placement of the architecture within it. With this arrangement, and only this arrangement, the setting becomes an expressive agent in the identification of the figures.

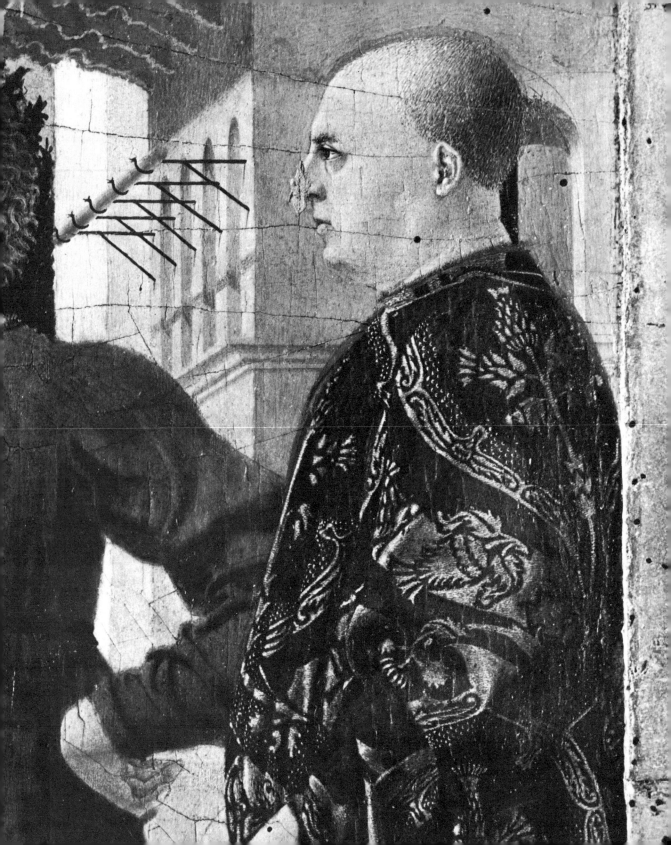

5. The Portraits

I believe that two of the figures in the foreground group can be identified on the basis of comparison with known portraits.[29] The man at the right standing in profile, his hands at his waist with his thumbs hooked in his belt, looks directly before him. He is elegantly dressed in Italian fashion, wearing a cloak of brilliant blue cut-velvet brocaded with gold threads in thistle patterns and loops. The garment is edged in fur, and a crimson scarf hangs over the shoulder extending below the hemline. On his feet are soft black leather boots, or *calzoni* [25]. He is bareheaded, with close-cropped gray hair shaved high in the back and at the sideburns. The crown of the head was changed by the artist on the panel. Through the final layer of paint, one can see the original, slightly higher outline of the top and slightly less bulging profile in the back.

This head may be compared with a profile view of a bronze bust [26] whose authorship is still a matter of debate (although it is

25 *(left). The Flagellation*, detail of 1

26 *(below). Ludovico Gonzaga*
(left profile), *c.* 1450. Anonymous

27 *(above left). Ludovico Gonzaga*, 1447–8. Pisanello

28 *(above right). Ludovico Gonzaga*, 1452–7. Pietro da Fano

frequently attributed to Donatello) but which is generally accepted as a portrait dating about 1450 of Ludovico III Gonzaga, Marquis of Mantua (1412–78). The identification was made in the late nineteenth century on the basis of comparisons with inscribed medals of Ludovico by Pisanello (1447–8) [27], and Pietro da Fano (1452–7) [28]. To these may be added comparisons of the right profile [29] and full face view of the bust [31] with similar views of Ludovico [30 and 32] in the fresco cycle painted in the early 1470s by Andrea Mantegna in the Camera degli Sposi in the Marquis's Mantuan palace.[30]

When the head in *The Flagellation* is juxtaposed with the bronze [25 and 26], their general configurations appear virtually identical. Both have broad, gently sloping foreheads, slightly flattened crowns, with the back of the skull and neck forming three distinct curves. The eyes are both shallowly placed and heavy-lidded, the temples broad, the bridges of the noses high and the nostrils fleshy. The mouths are stern and set, the chins slightly receding. Below each chin is a weighty bulge that hangs to the chest and then rises in a wide arc up to the ear. The hair in both is close to the skull, shaved at the sideburns, and the hairline at the nape of the neck continues the bowl-shaped curve that begins at the temple.

Admittedly the comparison presents some difficulties. In the painting a portion of the tip of the nose has chipped away, making it problematic to reconstruct its original shape. Enough remains of the bridge and the angle under the nostril to allow the possibility that it had the same fine, long, slightly down-curving profile as that of the bust. While similarly highly placed, the eyelid of Piero's figure is narrower and less plastic than that of the sculpture. The eyebrows are not the same; in the painting it is close to the eye and concentrated nearer the nose, lacking the flaring s-curve line of the sculpture. These differences may be due, not so much to physiognomic diversity as to the fact that one artist was painting a growth of hair, while the other was modeling the bony structure beneath it.

29. *Ludovico Gonzaga* (right profile), *c.* 1450. Anonymous

30 *(right)*. *Ludovico Gonzaga, c.* 1470. Mantegna, detail

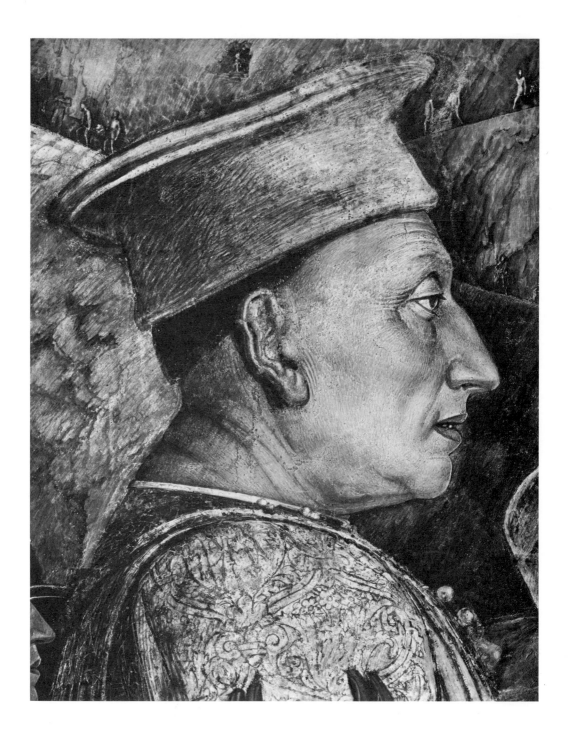

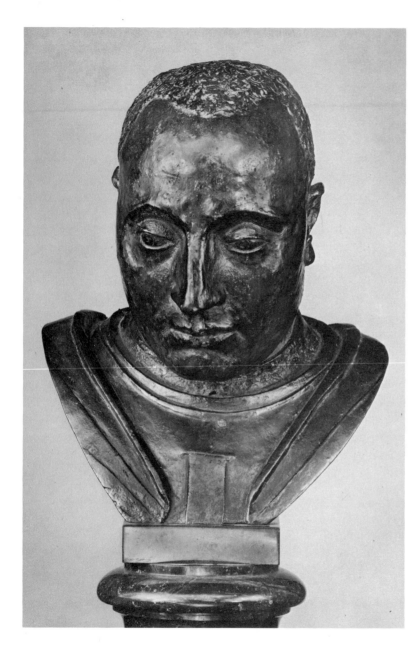

31. *Ludovico Gonzaga, c.* 1450.
Anonymous

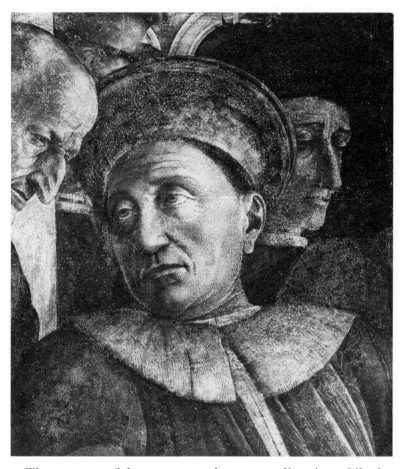

32. *Ludovico Gonzaga, c.* 1470.
Mantegna, detail

The contours of the ears create the greatest disparity: while the sculptured ear has an almost perfect question-mark-shaped outline, the painted ear is crumpled at the top with no reverse s-curve at the bottom. Analogous discrepancies, however, appear in other representations of Ludovico's ears. The full-face view of Ludovico by Mantegna [32] shows an ear that, like that of the sculpture, is widely flaring in the upper part and elongated at the lobe. But a front view of the sculpture [31] reveals by contrast that the contour of the ear is sharply broken half way down. There is also a vast difference between the right ear of the sculpture [29] with its curved top and straight slanting lower half, and the right ear of Ludovico in

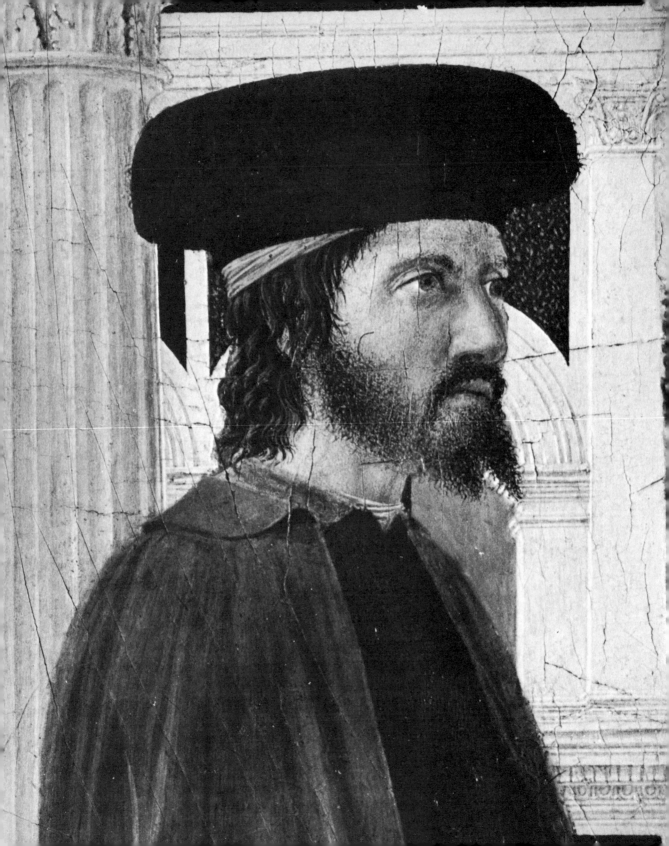

Mantegna's other fresco portrait [30], where the outline is curved in three irregular, lumpy scallops. It may be that Piero adjusted the shape of the ear to harmonize with the rounded hairline, as he had redrawn the top of the skull for greater harmony with the window arch juxtaposed to it. A more likely explanation, however, is suggested by the similarity the ear bears to that on the Pietro da Fano medal [28] where the upper edge of the trumpet is slightly flattened by the low-fitting headband of the bonnet. Perhaps the painted portrait was done after a medal of this sort.

To sum up, while the sculpture is younger, more energetic and muscular, the painting more objective, stately and impersonal, the similarities between the two likenesses outweigh their differences. In 1460 Ludovico would have been forty-eight years old, a plausible age for the grizzled figure in the painting. The domestic palace that forms his backdrop identifies him as a wealthy and prominent citizen and is thus consistent with the suggestion that he is the Marquis of Mantua.

But what, it may be asked, is the lord of Mantua doing in a painting whose provenance from its earliest documentation is the city of Urbino? The answer to this question depends on the identity of the other figures.

The man at the left of the group stands slightly deeper in space and turns in a three-quarters view to look at Ludovico [4 and 33]. His lips are parted, his right hand extended palm down at waist level in a gesture of emphasis, as though he were speaking. His face is covered by a black beard arranged in two stiff points. His hair grows long at the back. He wears a hat, over a white cloth turban, of a peculiar mushroom-shape made of black wavy-haired goat skin. (One should be careful not to read the strips of marble veneer on the building in the background as streamers on the hat.) His coat, deep raspberry in color, hangs over his shoulders with exaggeratedly long empty sleeves. This manner of dress, which impresses us immediately as being somewhat strange, corresponds closely to

33. *The Flagellation*, detail of 1

contemporary fashions in the Byzantine Empire, and specifically to those of Constantinople.

Firsthand information of Byzantine apparel had been gained in Italy in 1438-9 when a large delegation of easterners, including the

34. *Byzantines*, 1438. Pisanello

Emperor John Paleologus, came to Ferrara and then to Florence for a congress on the possible unification of the Western and Eastern churches.[31] Piero himself perhaps saw the delegation when as a young man he was studying and working in Florence. He might have made notes on the costumes at the time. Pisanello, an artist Piero much admired and frequently borrowed from, did just this, making a sketch of Joseph II, Patriarch of Constantinople [34],[32] wearing the very coat that adorns Piero's figure. The sketch also shows that the forked beard was in Byzantine style. The wavy fur hat can also be traced to the Greek entourage through a source likewise available to Piero. In three of the four scenes depicting events of the 1438–9 Council on Filarete's bronze doors for St Peter's, Rome, a higher and more globular version of the hat, is represented several times [35]. Wavy locks of fur hang on the crown, and in at least one instance, it is worn in conjunction with the long-sleeved coat.[33]

35 A, B. *The Arrival of Emperor John Paleologus,* 1445. Filarete

To be sure, all the headgear in the Flagellation scene proper is eastern in style. Pilate's hat, with conical crown and wide up-turned brim slit at the side and forming a long pointed visor in front, has often been recognized as closely related to that worn by John Paleologus himself.[34] It too is represented on the Filarete reliefs mentioned above, as is the brimless conical cap worn by the flagellator to the right, which is therefore also Constantinopolitan in style. The loosely wound cloth turban of the counselor with his back turned, on the other hand, can be localized to Egypt by comparison with several other figures in Filarete's reliefs, those representing the Abbot Andrew and ten monks of St Anthony who came to

Florence and Rome in 1441 as representatives of the Ethiopian Church.[35]

The figures in the Flagellation scene, however, represent persons who, on a literal level, were living in Jerusalem. Their mid-Eastern costumes are thus historically and geographically purposeful. What differentiates the bearded foreground figure is that he communes directly with a live Italian to whom in clothes and appearance, he forms a striking contrast.

There was one person in a high position at the court of Urbino with whom Ludovico Gonzaga had a life-long personal relationship and who, in a known portrait, was depicted with a black beard and cast in an exotic role. This was Ottaviano Ubaldini della Carda (c. 1423–98), coeval nephew and close companion of Duke Federico da Montefeltro. Owing to slanderous accounts of his activities written soon after his death, Ottaviano is nearly forgotten by history, whereas in all probability he was a prime mover in the intellectual and artistic environment that developed in Urbino. The grandson of Count Guidantonio by his daughter Aura (or Laura) da Montefeltro and Bernardino Ubaldini, famous condottiere, officially Ottaviano was chief counselor and treasurer of state. Often when Federico was away on missions of war, Ottaviano took over the full reins of government. After the duke's death in 1482, Ottaviano was regent during the minority of Prince Guidobaldo, and remained his chief counselor until his death in 1498.

Ottaviano, who received a superior Humanist education, was a man of great cultural gifts. Both a connoisseur and collector of art, in Giovanni Santi's rhymed *Chronicle* he is called 'exalted protector of painters and sculptors'. As early as 1442, two poems in praise of Pisanello were written in his name. Perhaps his greatest fame, however, rested on his achievements in the field of astrology, of which he was considered one of the most learned practitioners of his time. Santi's panegyric claims Ottaviano was so gifted in astrology he seemed to have been born to it ('Et in Astrologia docto tanto, Che verament a quel nato pareva'). The reader should bear in mind that

in the Renaissance, astrology was a highly respected science. Late in the Middle Ages chairs of astrology were introduced in Italian universities under the Faculty of Medicine. Then and throughout the Renaissance, those who held the chairs were venerated scholars, competent not only in astrology proper, but also in astronomy, geography, mathematics and optics. We may add that the study of perspective fell under the study of optics and was thus a branch of astrology. Astrological studies were not considered outside the limits of the church; many professors were priests and members of religious orders. The doctor and tutor of Prince Guidobaldo da Montefeltro, for example, was the Dutch astrologer-mathematician, Paolo di Middleburg, who late in life became Archbishop of Fossombrone. Fra Luca Pacioli, a Franciscan monk, mathematician, astrologer, and colleague of Piero della Francesca, referred in his writings to Ottaviano Ubaldini as 'the prince of living astrologers'.[36]

In 1488 Ottaviano was chosen to cast the horoscope to set the date of consummation of the marriage of Guidobaldo of Urbino and Elizabetta Gonzaga, who was Ludovico's granddaughter. (This was a frequent practice in the fifteenth century for the purpose of ensuring fecundity.) The marriage took place on 11 February, and the horoscope decreed the date of consummation as 2 May. The length of the wait, as may be imagined, caused some consternation on both sides of the family, and Ottaviano was petitioned to shorten the time. A new horoscope was cast which moved the date to 19 April. Unhappily, the marriage remained childless, and the Montefeltro line came to an end in 1508. Not long after, Cardinal Pietro Bembo in his *Life of Guidobaldo and Elizabetta*, blamed Ottaviano for this disaster. Bembo in fact imputed vicious crimes to Ottaviano saying that through his magic he had emasculated the young duke to prevent heirs, desiring the dukedom and properties of Urbino to be transferred to the Ubaldini family. It is now known that these imputations were all untrue, patently so as Ottaviano's only child had died long before, in 1458. Bembo it seems was using Ottaviano as a scapegoat on whom to blame the loss of Mantuan claim on the

rich properties of Urbino. Yet, all later historians of Urbino repeated Bembo's story, elaborating at times to accuse Ottaviano not only of magic but of using poison.[37]

Because of his astrological bent, Ottaviano was suggested in the late nineteenth century as the person represented in the guise of the Greek scientist Ptolemy in a painting representing *Astrology* [36]. This painting was one in a series of the Liberal Arts executed in the late 1470s by Joos van Ghent, a Flemish artist who lived for a time in Urbino. The painting, destroyed in the Second World War, originally hung in Federico da Montefeltro's study in his palace in the town of Gubbio, as pendant to the panel representing *Dialectic* in which Federico himself appears.[38] In the Astrology panel, a bearded figure in flowing robes kneels before an enthroned personification of Astrology from whom he accepts an armillary sphere, a model of Ptolemy's geodesic world. He is further identified as Ptolemy by the crown displayed on the steps; during the Middle Ages the ancient thinker had been confused with the Egyptian kings of the same name.

Comparison of this head [37] with what to my knowledge is the only inscribed portrait of Ottaviano proves the identification with finality. The portrait is a marble relief medallion [38] in the church of San Francesco in Mercatello sul Metauro, carved after Ottaviano was created count of Mercatello in 1474.[39] Shown again in right

36 *(opposite). Astrology, c.* 1475. Joos van Ghent

37 *(below left)*. Detail of 36

38 *(below center). Ottaviano Ubaldini,* post 1474. Anonymous

39 *(right). The Flagellation,* detail of 1

profile, he has a gently sloping forehead, a rather large down-turning, meaty nose, and mobile mouth with full lower lip. His rounded, somewhat sunken chin has an incipient flab below. His bearing is erect, the back of his neck straight. His hair waves gently and curls slightly at the ends. It is trimmed just above the tip of the ear, making a fringe at the nape of the neck and at the forehead. The eye is neither protruding nor sunken, but bears the indications of age (Ottaviano was fifty-one in 1474) in the puffy bag below.

In Joos's portrait [37] the forehead has been given a more decidedly 'intellectual' slant; although less fleshy, more aquiline and refined, the nose has the same downward turn, and the mouth, though pulled down at the corner, has the same mobility. The eye has the same placement, the same puffy bag, but of course is not blank; the gaze in fact is thoughtful, serious, and somehow sad. The major difference between the two heads is the fact that in the painting the face is bearded and the hair is shoulder length. The beard was tradition-ally associated with scholars and sages, and it may have been added here as an attribute of the astrological role Ottaviano is playing.[40]

But even more striking are the similarities Joos's portrait bears to the bearded head in Piero's painting [39]. There are in both the sloping brow, the gently curving eyebrow coming close to the outer corner of the eye, and the same down-curving lines from the under-eye to the sagging cheek. In both the eyes have a sad, serious gaze. Although seen from different angles, both noses are prominent and arched in a single down-turning curve. The mouths have the same sensitive mobility, sloping down at the corners. The only major difference is the texture of the hair and beards. Whereas Joos's are long, soft and curling, Piero's are shorter, stiff, and wiry. This dif-ference may be due entirely to the predilections of the two artists, for the same disparity in hair texture is observable between Piero's famous portrait of Federico da Montefeltro in the Uffizi and Joos's portrayal of Federico in the Gubbio Liberal Arts panel mentioned above. Since there is much evidence to show that Joos van Ghent was deeply impressed by Piero's work while he was in Urbino, it

seems likely that his portrait of Ottaviano with a beard was based on the head in Piero's earlier work.

I identify the bearded figure in Piero's foreground group as a portrait of Ottaviano Ubaldini in his capacity as astrologer. Here, unlike Joos van Ghent's version, he carries no direct symbols of astrology. Exoticism is merely suggested through the beard and clothes of eastern cut. The mushroom-shaped hat had been used before for this general effect, by Fra Angelico, another artist Piero admired. In a small scene of the *Adoration of the Magi* [40], one of the three Magi, who clasps hands with St Joseph in the right background (and who also has a forked beard), wears a mushroom-

40. *Adoration of the Magi*, 1433. Fra Angelico

shaped hat, broader and droopier than Ottaviano's but of the same type. In referring through this accessory to one of the Magi, or oriental wise men, Piero surely meant to fortify the image of Ottaviano as '*un gran Mago*', as he was called by his contemporaries.

Ottaviano's backdrop adds to this effect. His heels overlap the white pavement strip on which the columns of the Praetorium lie, and his body covers part of the column and most of the visible face of the two-story palace deep in space. The effect of this backdrop is to suggest that the figure is somehow privy to the inner sanctum, having access through his 'science' to superior insights.

6. The Subject

Ottaviano Ubaldini knew Ludovico Gonzaga most of his life. He probably met the Mantuan prince when, as a child, he was sent to study at the Gonzaga court school, La Giocosa, just outside Mantua. Their friendship was renewed in the late 1430s when for a period they were both in Milan learning the military arts at the court of Filippo Maria Visconti. In adult life their contacts were continuous, as is recorded by the many letters between them preserved in local archives.[41] Ludovico shared with Ottaviano a deep faith in astrology. We know from many sources that Ludovico's court always had professional astrologers on the staff, and that astrological prognostications influenced his every decision, political and personal. Ottaviano actually served as Ludovico's astrologer when, as we have seen, he cast the horoscope for the marriage of the marquis's granddaughter. Correspondence on astrological problems is preserved between Ottaviano and other members of Ludovico's family as well.[42]

The link between the two men in Piero's painting is the figure of the youth standing between them [4 and 41]. He faces the picture plane, weight on his right leg, left arm akimbo, gazing steadily at the spectator. He is differentiated from his companions in several ways. The first is his age; he is full grown but in the first flush of manhood. He does not wear contemporary clothes; his garment, mulberry in hue, is a simple peplos-style dress unadorned but for a green braided belt. As opposed to the molded leather boots worn by the other figures, his feet are bare. The upper part of his body seems to rise above the wall in the background and his head is silhouetted against green foliage. His face is full featured, his skin is fair, his hair is blond and curling. His eyes are clear and light, an unearthly color, nearly gold.

41. *The Flagellation*, detail of 1

Who is this beautiful young man and what is his relationship to Ottaviano Ubaldini and Ludovico Gonzaga? Toward 1460 Ottaviano and Ludovico both suffered tragic disappointments regarding sons in whom they had set paternal hopes. In July 1458, Ottaviano's son Bernardino was sent, along with another local prince, to study at the court of Naples. On their way, they payed a visit to the papal court and their Humanistic training and fine deportment there made a deep impression. From Rome, Bernardino and his companion proceeded to Naples. Upon their arrival they found the city ravaged by the plague. King Alfonso was gravely ill and died the same month. The boys fled, but not before both were stricken. The first boy died a few miles from Naples. Bernardino journeyed homeward, his condition worsening as he went. At last, in the town of Castel Durante, just a few miles from Urbino, he died. There are many records of his father's mourning, perhaps the most touching of which is the Latin Epitaph written by the Humanist Porcellio Pandonio. In florid terms the poem praises the son and immortalizes the father's love and irreparable loss.[43] No other children by Ottaviano are recorded.

Gonzaga's filial loss was also through illness. Though the youth was not one of his own sons, and he did not die, the tragedy that befell him seems to have been no less deeply felt. There had been rivalry between Ludovico and his younger brother Carlo for succession of the state in which Ludovico won out, becoming marquis in 1444. After this, Carlo went into self-imposed exile. Notwithstanding this animosity, when Carlo died in battle in 1456, Ludovico provided a home for his brother's widow and children. Among these was a bastard son named Vangelista, and it was this lad who became Ludovico's favorite. Vangelista was singled out in Mantuan history in the following way: he was said to be 'beautiful beyond belief, so beautiful that everyone spoke of it. At the age of sixteen he already showed the soldierly but generous spirit that made him dearly loved by the Marquis, who supported him. But after only a few

years at court, Vangelista contracted a disease from which he suffered two years, and which left him monstrously crippled and incapacitated, and caused him to lose all his beauty.'[44]

Vangelista was born in 1440 and the chronicles say his illness occurred between the age of sixteen and twenty, that is between 1456 and 1460. Thus tragedy struck him at almost precisely the time of Bernardino Ubaldini's death.

I believe these events, the death of Bernardino and the crippling of Vangelista, brought the two fathers together and caused the commission of Piero's painting. They are shown at the first moment of shared understanding as they discuss the significance of the double tragedy that had befallen them. The subject of their conversation takes shape between them in the image of a youth whose palpability of form and intensity of glance bring him into sharp contact with reality, while his ideal beauty, timeless garment and bare feet remove him to a symbolic realm. He is a figure of youthful perfection who personifies the 'beloved son'.

The chief feature that relates this figure to both ill-fated boys is his fairness; not only is his hair blond, but his skin tone seems considerably lighter than that of his companions. Fairness as a laudatory attribute was applied to both Bernardino and Vangelista on other memorial occasions. The dead Bernardino is called the 'ivory-colored youth' (*Eburneo Adolescêtu*) by the poet Porcellio Pandonio in a sixteen-line epigram in his praise. Vangelista is described by a fifteenth-century Mantuan chronicler as 'belo, grando, bianco' (beautiful, tall, white).[45] Here I would also like to call attention to a figure in Mantegna's *Court Scene* in the Camera degli Sposi, painted in the early 1470s, as we have already noted, in Ludovico Gonzaga's newly rebuilt palace. Almost in the center of the wall covered with life-size portraits of Ludovico and his family, stands an elegant youth [45]. In contrast to every other portrait in the room, this boy has curling blond hair. Tall and handsome, he is emphasized by his placement against a floriated pilaster and isolated by his

thoughtful, far-away glance. The striking similarity he bears to the blond youth [42] in *The Flagellation* does not appear to be chance, and I propose he is a memorial to Vangelista's pre-illness perfection.

Reinforcement for the idea that the allegory applies to sons from both families comes from another, rather unexpected quarter: namely the floral details. At the top and bottom of the wall [43] that forms part of the figure's backdrop are patterns similar to classical carved *rinceaux*. The scrolling vines are painted green and the many-petalled flowers that grow from them are colored brilliant orange-yellow. In order that they might be clearly visible at such a great distance from the picture plane, Piero made the blossoms very large in scale. Because of their placement, they seem to embrace the right arm of the boy. By calling attention to these flowers Piero has associated the figure with the Gonzaga family, one of whose *imprese* was a sunflower-like blossom. This emblem can be seen on the reverse of the Pisanello medal in illustration 44. Another floral pattern, to the boy's left, seems to refer to the Ubaldini family. The cut-velvet robe worn by the gentleman in profile is woven with the rather unusual motif of thistles. The full surname of the Urbinate branch of the family was Ubaldini della Carda. *Cardo* is the Italian word for thistle. If these observations are valid, Piero has subtly interwoven the dual reference, in terms of space and surface design, by putting Gonzaga flowers near the figure of Ubaldini, and the Ubaldini della Carda flower on Gonzaga.

A third floral element in close visual relationship to the blond figure is even more important in giving the key to his meaning. The leafy green foliage that frames his head as an essential part of his backdrop, in rational terms is far in the distance and high in the sky. Again Piero has enlarged the scale of the forms to bring them forward and make them visible. The genus is recognizable from the shape of the leaves and of the tree itself. It is a laurel, the tree that from classical times forward has been a symbol of Glory. Indeed the arrangement of the branches spreads like a wreath around the boy's

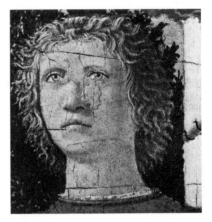

42, 43. *The Flagellation*, details of 1

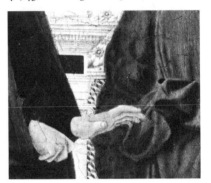

44. Reverse of 27

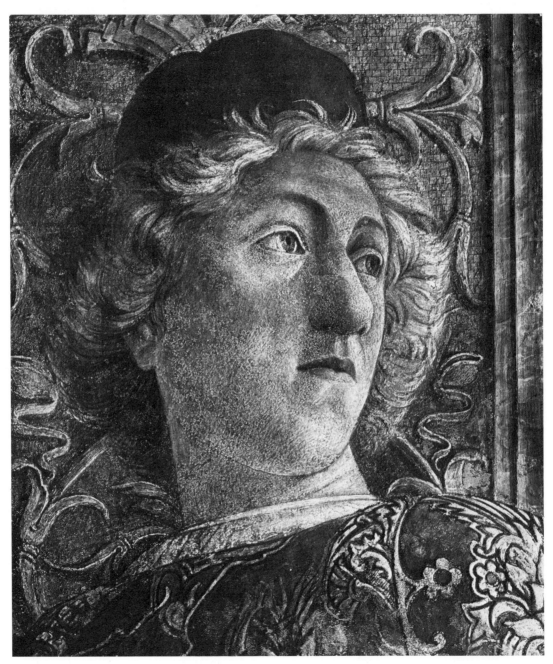

45 *Gonzaga Court Scene, c.* 1470. Mantegna, detail

74

blond curls. The image of the 'beloved son,' who in this world was felled by disease, in his ideal form is crowned with eternal Glory.

We observed at the outset that this youth is visually identified with the figure of Christ. Separated as they are by the space and mystical lighting, they are nevertheless drawn together by their central placement in a group of three, by the relative pallor of their skin, and by their poses, one *contrapposto* echoing the other. Through this reciprocity of tone and stance, the earthly 'beloved son' is compared to the heavenly 'Beloved Son', his physical decay likened to

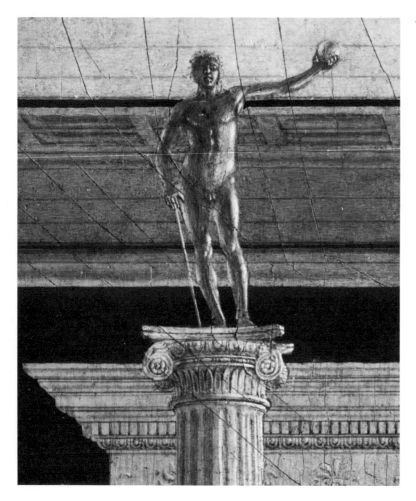

46. *The Flagellation*, detail of 1

Christ's physical torment. After the corruption of disease, the memorial of the worldly son is whole and beautiful, just as Christ remains unblemished by the Flagellation.

A final element completes the allusion and carries it to its richest level of meaning. This is the statue on top of Christ's column [46], a motif unprecedented in Flagellation iconography. For many reasons this small figure alludes to classical antiquity, the historical period of Christ's Passion. Its nudity and its pose (a third repetition of the *contrapposto*) relates it to various categories of classical hero-statues.

47. *St Catherine exhorting the Emperor; c.* 1428. Masolino

Placed on a free-standing column, it must be associated with triumphal monuments such as the columns of Trajan and Marcus Aurelius which were surmounted by statues of the emperor. Trajan, in point of fact, for a brief period in his reign had coins struck showing the statue of himself on his column, nude and holding a ball and sceptre.[46] Because Piero's statue is made of gold it has been interpreted as representing the classical sun god 'Sol', a huge figure of which was standing on a column near the Colosseum still in the fifteenth century.[47] But the way the statue rests its right hand on the top of its staff alludes to another antique type, that of Hercules resting his hand on his club. The figure's general form is identical with the statue in Masolino's fresco *St Catherine exhorting the Emperor* in San Clemente, Rome, painted about 1428 [47], which holds a ball and is placed on a column. Masolino's statue is the pagan idol which Catherine exhorts the emperor to throw down.

Piero's statue, however, is more than a reference to pagan antiquity. Both Apollo and Hercules were thought of as classical forerunners of Christ. Moreover, the silvery sphere in the statue's extended left hand is an imperial sign of universal sovereignty, frequently applied to Christ. In other words, Piero has given the statue attributes describing the pagan qualities that Christ himself embodied and superseded.

The statue's meaning is extended by its triumphal position on the column of the Flagellation. Like the laurel above the head of the blond youth, it is a symbol of Glory, and in this context specifically Christian Glory. Not long after Piero's painting, Domenico Ghirlandaio made this meaning explicit. On the external pier of Ghirlandaio's Sassetti Chapel decorations in Santa Trínita, Florence (1483-6), there is a monumental fresco representation of a *Statue of David* [48], an Old Testament forerunner of Christ, placed on a tall pilaster. On the base of the statue is an inscription proclaiming its dedication 'To the Health of the Fatherland and of Christian Glory'[48]. The statue-on-a-column motif ultimately became a standard symbol of Glory and as such was included by Cesare Ripa

48. *Statue of David*, 1483–6.
Domenico Ghirlandaio

in his compendium of visual symbols, *L'iconologia*, published at the end of the sixteenth century. Ripa says one must 'put a statue on top of a large column . . . with a crown of laurel in the right hand and a staff in the left' to represent *Sublimità della Gloria*. His text is accompanied by an appropriate woodcut illustration [49]. The apparition of the Flagellation in Piero's painting thus represents Christ enduring worldly suffering specifically as the 'Lord of Glory'.

The analogy with the foreground is complete in every way; in meaning as well as in form the two groups come together. It is perhaps this 'coming together' that explains the somewhat mysterious inscription, *convenerunt in unum*, now lost, but which was most probably in the center of the lower frame. This three-word phrase is part of the second verse of Psalm 2. In full, the verse speaks of the kings and princes of the world coming together and setting themselves against the Lord. It is cited in the Acts of the Apostles (iv, 25-7) as pertaining to the conspiracy against Christ that brought about his Passion. In the Roman Breviary, the complete verse forms the Antiphon of the first Nocturne of the Good Friday service. It thus has liturgical meaning for any passion scene and, by extension, for the Flagellation.[49] Nevertheless there must be a reason why only these three words were quoted here. I propose that, while retaining the liturgical connotation, the phrase was lifted out of context and set down in isolation to emphasize the face value of the words, meaning 'they come together'. Placed in the center of the composition and therefore relevant to the whole composition, they said clearly and simply, in this painting, two themes, one from life and one from the Gospel, *convenerunt in unum*. In both groups, the underlying theme is the triumph of Christian Glory over the vicissitudes of this world.

The painting's message is, then, one of consolation. Theologically, the theme is rooted in the writings of St Paul where the correlation between tribulation and glory is frequently expounded.[50] Ideologically, it takes its place in the larger body of consolatory expressions, more familiar to Humanist tradition in the epistolary form, the Letter of Consolation, and in orations. In conveying the message

SVBLIMITA' DELLA GLORIA.

49. *Sublimità della Gloria*. Woodcut from C. Ripa: *Iconologia*, 1618

visually, it is the bearded foreground figure who acts as guide and informant. He has found the way to consolation from seemingly incomprehensible loss, and imparts the insight to his companion in grief.

The figure's exotic appearance, which casts him in the role of Wise Man, and his physical identification with the divine sanctuary, which marks his powers of understanding as beyond those of ordinary men, lead to the suggestion that he gained his insight through study of the stars. This idea is reinforced by several indications of astrological thinking of a truly esoteric nature within the composition itself. The plotting of the figures on the reconstructed plan, for example, when conceived in graphic terms, strongly resembles the visual form of astrological prognosticons. The geometric floor pavements in the front and back bays of the Praetorium, disguised by their perspective foreshortening, are similar in design to certain kinds of Renaissance horoscope drawings. Recent studies have shown these pavement designs, in their reconstructed state, to be special purveyors of mathematical symbolism. The eight-pointed stars that form their central motifs, moreover, are the astrological sign for the planets.[51]

These 'hidden' references lend credence to the identification of the bearded figure as Ottaviano Ubaldini, the master astrologer. Ottaviano would not only have been capable of following the intricate workings of the painting's perspective, but also would have been able to make his own contributions to it. Further, the technique of linear perspective, a sub-branch of astrology, was pursued and ultimately invented in the basic conviction that all visible experience is reducible to numerical equations. This mathematical order, it was believed, is a reflection of the divine order of the universe.[52] In this context, the overriding prominence of the perspective itself becomes meaningful. Ottaviano called on Piero, the master mathematician, to provide an important perspective framework, with astrological overtones, to illustrate the inevitable place of consolation within the scheme of God's order.

Taking the death of Bernardino Ubaldini (1458) and the crippling of Vangelista Gonzaga (1456–60) as *termini post quem* for the commission, Piero would have been carrying out work on *The Flagellation* simultaneously with the later phases of his Arezzo fresco cycle [50]. This dating, first suggested by Clark,[53] is corroborated

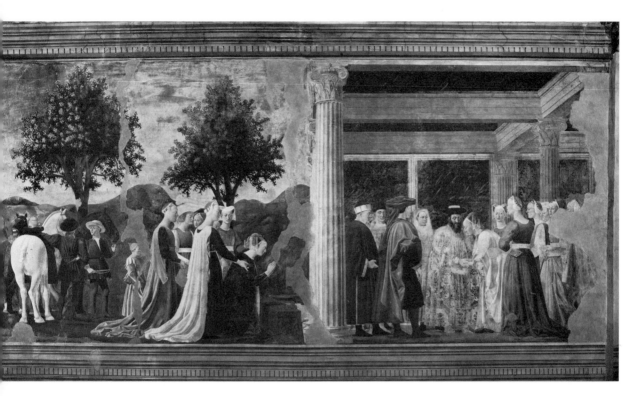

50. *The Queen of Sheba's visit to Solomon.*
Piero della Francesca

by the many parallels between the two projects in architectural forms and in costumes, as well as in style. It also fits with the physiognomic ages of the portraits: in 1460 Ottaviano was thirty-seven and Ludovico was forty-eight.

If Ottaviano Ubaldini was the guiding force in the commission, remembering its Urbino provenance, he was also the probable owner of the painting. Since we happen to know that at one point he received permission from Pope Sixtus IV to worship at a portable altar,[54] we are assured he had use for a private devotional image.

Even more significant is the fact that in the Ducal Palace of Urbino, where Ottaviano lived, there is a small chapel, the Cappella del Perdono, that was at least after 1482 under his patronage. This magnificent little room, exceptional in the palace because of its marble incrustation, corresponds exactly in its small dimensions and apse-ended rectangular plan to the San Sepolcro Rucellai in Florence [14 and 51]. Although it was probably finished somewhat later, the chapel would thus have made a sympathetic home for the painting. Because the chapel's altar is built into the apse wall and surmounted by a semi-circular niche, the panel could not have served as an altarpiece. Rather it might have been placed below as an altar frontal, one step above floor level. The dimensions of this area (c. 75 x 100 cm.) could in fact accommodate the painting (58·4 x 81·5 cm.) with its frame [52].[55]

The suggestion of a low placement for *The Flagellation* may seem somewhat surprising, and yet it reveals a remarkable aspect of the painting's conception. The vanishing point of the perspective is not in the center of the rectangle, but relatively low, at about the level of the right hip of the flagellator with his back turned. As a result, when the painting is viewed at eye-level or above, the space seems to run uphill. Furthermore, the proportions of the foreground figures are consistently long-waisted; their legs seem relatively short while their arms are overly long. This effect accounts for much of their looming quality. On the other hand, when the painting is seen below eye-level (which I had the opportunity to do while studying the panel on an adjustable easel), the spatial projection runs back without distortion, the architecture gains in effectiveness, and the proportions of the figures straighten out. The irregularities are thus in reality optical refinements, indicating that the composition was planned to be viewed slightly from above.[56]

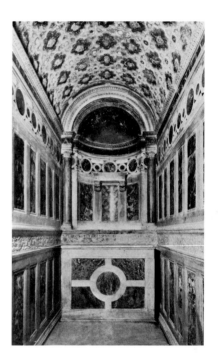

51 *(below)*. Cappella del Perdono, Ducal Palace, Urbino, 1474–6?

52 *(right)*. The *Flagellation* as altar frontal: photomontage

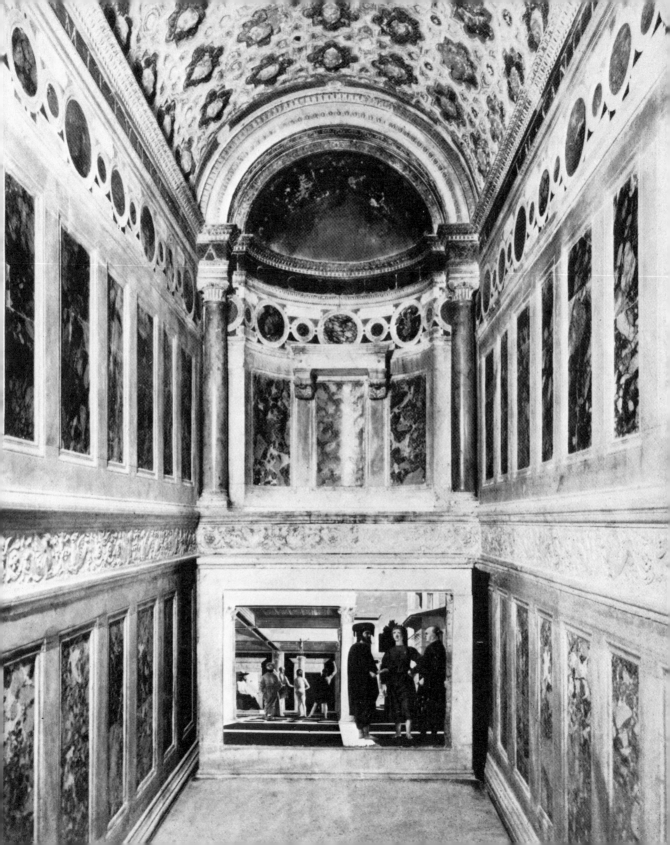

53. *Sigismondo Malatesta before St Sigismund*, 1451. Piero della Francesca

7. Art Historical Context

The historical significance of *The Flagellation*'s perspective construction has never been doubted; it stands today as, and probably always will remain, the high point of Early Renaissance three-dimensional illusionism. The painting's revolutionary contribution in the field of subject matter, however, has perhaps not been fully appreciated. Never before had mathematical pictorial space served such specific symbolic and expressive purposes. And even more startling, never before had donor portraits been made to 'act out' their own private drama in direct relationship to sacred figures. When seen in the context of Piero's own career, these innovations find ample resonance. It can be shown, in fact, that both before and after *The Flagellation*, he was deeply preoccupied with these very problems.

In the fresco of *Sigismondo Malatesta before St Sigismund* [53] in San Francesco in Rimini, dated 1451, and in the small panel, *St Jerome and Gerolamo Amadi*, in the Venice Academy [54], the donors are represented on the same scale as the patron saints and share with them equal prominence in the pictorial space. In both cases, the saint turns toward his devotee in direct and personal communication. In both, the setting plays a meaningful role in the expressions of their relationship. St Sigismund, historically a king, receives homage from the Prince of Rimini in his royal chamber. The visit, however, is reciprocal, for Malatesta is 'at home' with his dogs and the circular but realistic view of his own palace. St Jerome, perhaps for the first time, receives a living mortal in his desert retreat. At the same time, the hermit's penitential realm is located in the environs of an Italian town, depicted in the background, presumably the donor's own. Were we to learn more about Gerolamo Amadi as a personality, moreover, I have no doubt we would find

54 *(left). St Jerome and Gerolamo Amadi.*
Piero della Francesca

55. *Madonna and Child
with Saints and Federico da Montefeltro,*
1472-4. Piero della Francesca

specific meaning in the grimace St Jerome directs toward him. In both works, while the portrait figures have the same pose as countless earlier praying donors, their aggrandizement brings to them new significance as historical individuals. Piero has transformed the traditional votive imagery into an intimate relationship between living individuals and their holy prototypes.[57] In these paintings we find the non-narrative counterpart for the 'donor-actor' he introduced in *The Flagellation*.

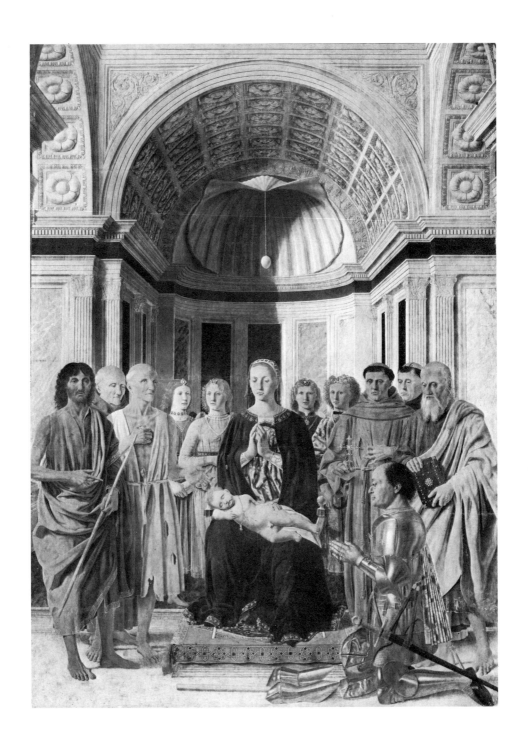

Somewhat after *The Flagellation* in another work for Urbino, Piero carried forward his earlier achievements in rationally constructed spatial symbolism. The *Madonna and Child with Saints and Federico da Montefeltro* [55], Brera Gallery, Milan, 1472-4, is set in the nave of a sumptuous basilica. The organization of the perspective places the apse of the church far in the distance, more than forty feet behind the figures. As in *The Flagellation*, however, the background structure *looks* directly juxtaposed to them, on a dwarfed scale. By this backdrop arrangement, Piero gives the image of the Madonna and Child the symbolism of 'Mary-Ecclesia', that is, Mary as a symbol of the Church as a corporate institution, traditionally illustrated by a change in scale. His purpose, as it had been in *The Flagellation*, was to provide personal significance for the figure of the donor, once more pressed close to the picture plane. Federico da Montefeltro is depicted in a full suit of armor, with helmet, gauntlets and baton of command. He is the first such armored donor in seventy-five years of Italian painting. In August of 1474 Federico was created Knight of St Peter's, Gonfaloniere of the Church of Rome, and general of the Vatican armies. Piero shows him, not as a traditional supplicant asking for protection or giving thanks, but pledging himself as a Soldier of Christ, an eternal sentinel guarding the Holy Roman Church.[58]

Piero's innovations were recognized and understood by his contemporaries, and we close our discussion with two instances where his legacy can be seen. In the Sassetti chapel, Santa Trínita, Florence, the same chapel in which we observed the monumental image of the statue-on-the-column with a meaning close to Piero's, there is a direct reflection of his use of space for temporal symbolism. Ghirlandaio's frescoes inside the chapel are a cycle of scenes from the life of St Francis. On the second register over the altar is *St Francis Presenting his Rule to Pope Honorius III* [56]. Although this event is one of the most important in the saint's career, it is relegated to the middle ground of the composition. In the foreground we find Angelo Poliziano and a number of young students ascending a flight of

56. *St Francis presenting his Rule to Pope Honorius III*, 1483–6. Domenico Ghirlandaio

stairs, at the top of which stand Lorenzo de' Medici and older members of the Sassetti family. An ideological parallel is established between the poet-teacher Poliziano and his students advancing toward the ruler of State, and the monastic innovator St Francis and his followers approaching the head of Church. In Ghirlandaio's scene, the spatial ambient is a unified view of contemporary Florence, and the two events are depicted in two horizontally disposed processions. Reflection of Piero's arrangement is found in the fact that the contemporary secular group is in the foreground while the religious scene, which occurred some two hundred and fifty years before, to which it is compared, is deeper in space.[59]

Our last example, whose ideological dependence on *The Flagellation* is even closer, was done in Urbino at a time when Piero him-

57. *Communion of the Apostles*, 1473-4. Joos van Ghent

self was probably present, and by an artist whose subsequent career was profoundly shaped by this contact. The Fleming Joos van Ghent, whose *Astrology* panel we have already encountered [36], painted a *Communion of the Apostles* for the high altar of the church of Corpus Domini in Urbino in 1473–4 [57]. Depicted at the right of the communion scene are Federico da Montefeltro, Ottaviano Ubaldini and two other members of the family. With them is a Spanish Jew named Isaac who was in Urbino in 1472–3 as ambassador from the Shah of Persia. From a series of documents we know that just before he came to Urbino, Isaac was converted to the Catholic faith. In the painting he is allowed to witness the archetype of the Eucharistic mystery at close range. His gesture, with his hand over his breast, is a profession of faith in what he sees. Federico and Ottaviano, through their gestures, offer encouragement to persist in his new faith.[60] Thus in a monumental altarpiece, destined for public view, the artist showed living figures, not in traditional kneeling positions, but standing in the space of the Holy Liturgy and commenting on it in terms of their own immediate experience. Joos did not use the kind of spatial symbolism he found in *The Flagellation*. But his interweaving of contemporary and mystical subjects could only have been derived from a full knowledge of the meaning of Piero della Francesca's earlier work.

Notes

1. This monograph is a somewhat broadened version of the material in my article 'Piero della Francesca's *Flagellation*: the Triumph of Christian Glory,' *Art Bulletin*, vol. 50, 1968, pp. 321-42. In the notes that follow I shall refer to this article simply as *Lavin*.

2. Piero's writings are: *De prospectiva pingendi*, which exists in two manuscripts, one in Italian (ed. G. Nicco Fasola, Florence, 1942), the other translated into Latin (ed. C. Winterberg, Strasbourg, 1899). *Libellus de quinque corporibus regularibus* (ed. G. Mancini, *Rendiconti dell'Accademia nazionale dei Lincei*, Rome, 1915). *Del abaco*, Cod. Ashb. 359, Biblioteca Laurenziana, Florence (ed. G. Arrighi, Pisa, 1970). See the section on Piero by Giorgio Vasari, *Le vite de' più eccellenti pittori scultori e architettori*, ed. G. Milanesi, Florence, 1906, vol. II, pp. 487-501, and in English translation, *The Lives of the Painters, Sculptors and Architects*, ed. W. Gaunt (Everyman's Library), New York, 1963, vol. I, pp. 331-6. Cf. the catalogue, *Mostra di quattro maestri del primo rinascimento*, Florence, Palazzo Strozzi, ed. 1954, no. 41, pp. 102f., for references to eighteenth and nineteenth century bibliography.

3. A. Venturi, *Storia dell'arte italiana*, Milan, 1911, vol. VII, pt. I, p. 464; R. Longhi, *Piero della Francesca*, Milan, 1927, most recent re-edition, Florence, 1963, pp. 25-8, with large photographic corpus and complete bibliography to date of publication. B. Berenson, *Piero della Francesa: or the Ineloquent in Art*, (first published in Italian, Florence, 1950), English ed., New York, 1954, pp. 4-5. A. Huxley, *Along the Road*, New York, 1925, p. 189. P. Guston, 'Piero della Francesca: the Impossibility of Painting', *Art News*, vol. 64, 1965, pp. 38-9. For a summary of critical appraisals, see also O. Del Buono, *L'opera completa di Piero della Francesca*, catalogue by P. De Vecchi (Classici dell'arte, 9), Milan, 1967, no. 11, p. 90.

4. Cf. *Lavin*, 'The Traditional Interpretation', pp. 331-4.

5. The 'Turkish Question' was introduced by F. Witting, *Piero della Francesca*, Strasbourg, 1890, p. 122f. See also C. de Tolnay, 'Conceptions religieuses dans la peinture de Piero della Francesca', *Arte Antica e Moderna*, vol. 23, 1963, pp. 205ff. Clark's discussion is in *Piero della Francesca*, London, 1951, pp. 19ff.; revised ed., 1969, pp. 33ff.

Gombrich's notes are in *Burlington Magazine*, vol. 94, 1952, pp. 176ff., and *Journal of the Warburg and Courtauld Institutes*, vol. 22, 1959, p. 172.

6. C. Gilbert, 'On Subject and not-Subject in Italian Renaissance Pictures', *Art Bulletin*, vol. 34, 1952, pp. 202–16; and idem, *Change in Piero della Francesca*, Locust Valley, N.Y., 1968, pp. 33ff. and p. 107.

7. Cf. J. White, *The Birth and Rebirth of Pictorial Space*, London, 1957, 2nd edn, Boston, 1967. R. Wittkower and B. A. R. Carter, 'The Perspective of Piero della Francesca's "Flagellation" ', *Journal of the Warburg and Courtauld Institutes*, vol. 16, 1953, pp. 292–302. While demonstrating the perfect geometry of the construction, the authors observe the loose handling in the final execution, which is full of minute and willful discrepancies. F. Casalini, 'Corrispondenze fra teoria e pratica nell'opera di Piero della Francesca', *L'arte*, 1968, vol. 1 (new series), no. 2, pp. 82ff.; the conclusions here must be tempered by the fact that the author mistakenly believes the panel was cut at the bottom (see below, p. 16).

8. Since this book was written, a new counter-proposal was put forth: C. Gilbert, 'Piero della Francesca's *Flagellation*: The Figures in the Foreground,' *Art Bulletin*, vol. 53, 1971, pp. 41–51. It does not meet the challenge, however. The author, having renounced his earlier position (see above, note 6), now views the painting as a biblical narrative with an 'ordinary' composition, and leaves unexplained all the extraordinary features of its form and organization.

9. J. D. Passavant, *Raphael von Urbino und sein Vater, Giovanni Santi*, Leipzig, 1839, vol. I, p. 432f. J. A. Crowe and G. B. Cavalcaselle, *The New History of Painting in Italy*, London, 1864, vol. II, p. 546.

10. The restoration reports are: G. Urbani, 'Schede di restauro', *Bollettino dell' Istituto Centrale del Restauro*, vol. 9–10, 1952, pp. 181–2; C. Brandi, 'Restauri a Piero della Francesca', *Bollettino d'Arte*, vol. 39–40, 1954–5, pp. 241ff.

11. Ghiberti's scene is on the north doors of the Baptistery, Florence; cf. R. Krautheimer and T. Krautheimer-Hess, *Lorenzo Ghiberti*, Princeton, 1956, pp. 127–32. Andrea del Castagno's *Flagellation* was a fresco in the cloisters of Santa Croce, Florence, destroyed in the seventeenth century. His composition was described by Vasari and is believed to be reflected in an engraving by the Master of the Vienna Passion (see A. M. Hind, *Early Italian Engraving*, New York, 1938, vol. I, p. 38, vol. II, pl. 28; reproduced also in *Lavin*, fig. 10). Quite likely, the Siena Baptistery fresco, frequently attributed to Vecchietto, was also influenced by Castagno's composition; cf. *Lavin*, n. 9.

12. The genesis of this tradition was apparently Duccio's small representation of the Flagellation on the back of his *Maestà*, 1308-11, Opera del Duomo, Siena.

13. The central panel of the altarpiece of which *The Flagellation* is a predella, represents a Resurrected Christ, frequently cited as a prototype of Piero's famous *Resurrection* fresco in the Palazzo Comunale, Borgo San Sepolcro. See the references in *Lavin*, n. 15. The relationship of Piero's *Flagellation* to the predella scene has not been noticed before.

14. G. Vigni, *Pittura del due e trecento nel museo di Pisa*, Palermo, 1950, p. 86, no. 70; also G. Kaftal, *Iconography of the Saints in Tuscan Painting*, Florence, 1952, pp. 945-6, no. 289 (b).

15. The basis for my discussion is the analysis by R. Wittkower and B. A. R. Carter, 'The Perspective of Piero della Francesca's "Flagellation"', *Journal of the Warburg and Courtauld Institutes*, vol. 16, 1953, pp. 292-302. Their reconstructed plan (illustration 11) must be corrected in one respect: the first and third decorated pavement sections on the left should not have the geometric patterns as shown, but the same circle-in-the-square motif as the second section on the right. We may see how Piero constructed such a view in the perspective drawing of an inlaid pavement in his *De prospectiva pingendi* (see illustration 12).

16. Cf. ibid., p. 300 n. 1, where the scale of the picture to life is given as 1:3·273.

17. Leon Battista Alberti, *Ten Books on Architecture*, ed. J. Rykwert, trans. J. Leoni, London, 1955.

18. The Rucellai project included the chapel, a palace, and a separate loggia [14, 15, 18, 19]. Construction of the chapel was completed in 1467. Cf. M. Dezzi Bardeschi, 'II Complesso monumentale di S. Pancrazio a Firenze ed il suo restauro', *Quaderni dell' Istituto di Storia dell' Architettura* (Facoltà di Architettura, Università di Roma), vol. 13, 1966, pp. 1-66, esp. pp. 22, 24f., and n. 56. K. Clark, *Piero della Francesca*, London, 1951, pp. 19, 33f., suggests that Piero was in Florence in 1458.

19. The most important discussion of the Rucellai Chapel is L. H. Heydenreich, 'Die Cappella Rucellai von San Pancrazio in Florenz,' *De Artibus Opuscula XL, Essays in Honor of Erwin Panofsky*, ed. M. Meiss, New York, 1961, vol. I, pp. 219ff. This study was extended by M. Dezzi Bardeschi, 'Nuove ricerche sul San Sepolcro nella Cappella Rucellai a Firenze,' *Marmo*, vol. 2, 1963, pp. 135-61. The practice of making replicas of the Holy Sepulchre was part of a long tradition beginning in early medieval times; cf. R. Krautheimer, 'An Introduction to an "Icono-

graphy" of Medieval Architecture', *Journal of the Warburg and Courtauld Institutes*, vol. 5, 1942, pp. 1–33. See also Q. Van Regteren Altena, 'Hidden Records of the Holy Sepulchre', *Essays in the History of Architecture Presented to Rudolf Wittkower*, ed. D. Fraser *et al.*, London, 1967, pp. 71ff.

20. H. Vincent and F.-M. Abel, *Jérusalem*, vol. II, *Jérusalem Nouvelle*, vol. II, Paris, 1922, 'Le Prétoire', pp. 562–86.

21. 'Viaggio di Gerusalemme,' Bibl. Vat. MS Chigi M. VII. 150, incip. 'Questo libro contiene del viaggio di Sancta Katerina et del sepulcro di Nostro Signore Iesu Christo et di multe notabile cose,' dated internally.

22. 'DOV'È ERANNO LE CASE DI PILATO: Tuctavia andando christo p la strada trovi un terzo. et descendendo trovi sopre la strada un bello arco et qui era *le case di pilato* dove christo fu presentato. Et segondo li evangelio di nicodemo quando iesu christo intrò al pretorio di nanti ad pilato stavano VI homini i quali tenevano VI bandere. le quale bandere come christo intrò subito glie fecero riverentia in presentia di pilato. Sotto la *scala* glie dove christo fu posto in presone. et ligato ala colona et bactuto et incoronato di spini. et beffato dicendo dio te Salve re de li giudei. Et incapo de la *scala* ad parte dextra glie la sedia dove pilato sedeva. et il populo stava in mezo de la *piaza* et gridava mora iesu et sia crucifisso. Donde pilato audendo il grande remore et havendo paura lu mise in man deli zudei et lui senelavo le mani. Et nel arco sopradicto stanno due grande prete quadre scripte di lettere greche hebraice et latine. Le quale se dice c̄h serranno testimonianza al di del uiditio de la morte di christo. E glie pdonanza. VII anni et LXX di,' (fol. 26r., Italics mine).

23. See *Lavin*, n. 25.

24. Because both the lower and upper extremities of this building are visible and its length could be found by measuring the shadow it casts, its height could be calculated. Cf. *Lavin*, p. 329.

25. 'Cosmographie Ptolemaei Viriale Xandrini,' Bibl. Vat. MS Urb. Lat. 277, fol. 132v. Ptolemy's original text was introduced to Florentine intellectual circles around 1400; the 1472 translation was made by Jacopo d'Angelo de Scarperia. See also a view of Jerusalem (the Holy Tomb and Mosque of Omar), in a French Book of Hours, by the miniaturist of King René, about 1436, London, British Museum, Egerton MS. 1070, fol. 5; most recently reproduced in C. H. Krinsky, 'Representations of the Temple of Jerusalem before 1500', *Journal of the Warburg and Courtauld Institutes*, vol. 33, 1970, pl. 5a.

26. The column fragment is mentioned on fol. 13r. of the 'Viaggio' manuscript (cf. Vincent and Abel, *Jérusalem Nouvelle*, vol. II, p. 255); the depression ('pozo'), on fol. 13v. (cf. ibid., p. 256, 276).

27. G. Moroni, *Dizionario di erudizione storico-ecclesiastica*, Venice, 1841, vol. VI, p. 55.

28. We have seen precedence for this idea in the Pisan processional panel [9]. There, if the scene of the Flagellation is viewed from the point of view of the donors (the kneeling confraternity members), it is a miraculous apparition.

29. It has often been pointed out that throughout his career Piero seems to have preferred certain facial types which he repeated and varied for all occasions. It is claimed that the foreground figures in *The Flagellation* cannot be portraits because they correspond with other presumably generic figures in various compositions of both earlier and later dates. The face of the bearded figure on the left, for example, is generally similar to Pilate's and to that of Constantine in the Milvian Bridge scene in the Arezzo fresco cycle. His mushroom-shaped hat, his cloak, and the style of forked beard are repeated several times in the same cycle. The ethereal face of the blond figure in the center is compared with one of the angels in Piero's *Baptism* in the National Gallery, London; it corresponds typologically with several angelic boys in Piero's other works as well. The pose and facial type of the gray-haired figure on the right is found again, facing the opposite direction, in the *Meeting of Solomon and Sheba* at Arezzo [50]; many aspects of his profile parallel one of the praying confraternity members in the *Madonna della Misericordia* in Borgo San Sepolcro.

On the other hand, it can also be shown that in a number of instances, faces which are known to be portraits conform to Piero's standard types. The famous portrait of *Battista Sforza, Countess of Urbino*, in the Uffizi, is a case in point, for women with similar features, shaped heads, eyes, and carriage in general, appear repeatedly in Piero's works, both as Madonnas and as 'bystanders' in narrative scenes. Even more relevant in the present context is the portrait of the kneeling donor in the small *St Jerome and Gerolamo Amadi* [54] (Venice Academy). The head of this figure has many elements in common with the man in profile on the right of *The Flagellation*; his pose and costume are identical to the *Misericordia* devotee. Nevertheless, he is certainly a portrait. It is clear, therefore, that Piero's physiognomic representations tend to conform to standard types,

but conformation to these types does not, in principle, preclude their being portraits of real people.

30. H. Grimm, 'Italienische Porträtbüsten des Quattrocento', *Preussische Jahrbücher*, vol. 51, 1883, p. 407. See also H. Kauffman, *Donatello*, Berlin, 1953, p. 138f. Full views of the Mantegna frescoes are found in E. Tietze-Conrat, *Mantegna*, London, 1955; they were finished by 1474.

31. Cf. J. Gill, *The Council of Florence*, Cambridge, 1959.

32. The identification of the figure in Louvre drawing MI 1062 was made by J. Fasanelli, 'Some Notes on Pisanello and the Council of Florence', *Master Drawings*, vol. 3, 1965, pp. 36–47.

33. The doors are dated 1445; M. Lazzaroni and A. Muñoz, *Filarete, scultore e architetto del secolo XV*, Rome, 1908, fig. 57 (Paleologus leaving Constantinople), fig. 58 (Meeting of Paleologus and Pope Eugenius IV), fig. 60 (Paleologus departing from Venice).

34. Paleologus' hat is known from several sources including a medal by Pisanello. Because of the similarity, Piero's figure of Pilate has been identified as representing the Greek Emperor; J. Babelon, 'Jean Paleologus et Ponce Pilate', *Gazette des Beaux-Arts*, Ser. 6, vol. 4, 1930, pp. 365ff.; but see also C. Brandi, 'Restauri a Piero dell Francesca', *Bollettino d' Arte*, vol. 39–40, 1954–5, p. 248, n. 5.

35. Lazzaroni – Muñoz, *Filarete*, figs. 64, 65.

36. See the references in *Lavin*, ns. 73, 77, 78, 80, and 81.

37. Petri Bembi, *Opera*, ed. L. Zetzueri, 1609, vol. I, 'De Guido Ubaldo & Elizabetha Ducibus Urbini', pp. 531–623, esp. p. 613. The accusation reappears in the seventeenth century in Bernardino Baldi's vignette of Ottaviano in his *Della vita e dei fatti di Guidobaldo I da Montefeltro, duca d' Urbino*, ed. Milan, 1821, vol. I, pp. 21ff., and in the nineteenth century in F. Ugolini, *Storia dei conti e duchi d'Urbino*, Florence, 1859, vol. II, p. 43. The case is reviewed and documented in Ottaviano's favor by A. Luzio and R. Renier, *Mantova e Urbino, Isabella d'Este ed Elisabetta Gonzaga*, Rome-Turin, 1893, pp. 31ff., 77ff.

38. The identification was made by A. Schmarsow, 'Ottaviano Ubaldini in Melozzo's Bild und Giovanni Santi's Versen', *Jahrbuch der preussischen Kunstsammlungen*, vol. 8, 1887, pp. 68ff. For attribution and original location of the painting, see M. Davies, *Les primitifs flamands: The National Gallery, London*, Antwerp, 1954, vol. II, pp. 142ff.

39. E. Rossi, *Memorie ecclesiastiche della diocesi di Urbania*, Urbania, 1938, vol. II, p. 157.

40. Still today the yearly almanac sold at news-stands in January throughout Italy, a modern parallel to the fifteenth-century annual predictions, is entitled *La barba nera* (The Black Beard). The prognostications for the year are given in the form of a dialogue between two comic-strip astrologers, one of whom is called 'Dott. Barba Nera'.

41. See references in *Lavin*, ns. 74–6.

42. F. Gabotto, *Bartolomeo Manfredi e l'astrologia alla corte di Mantova*, Turin, 1891; A. Luzio, *La galleria dei Gonzaga venduta all'Inghilterra nel 1627–28*, Milan, 1913, p. 20; A. Luzio and R. Renier, *Mantova e Urbino*, Rome-Turin, 1893, pp. 80ff.

43. Bibl. Vat. MS Urb. Lat. 373, fols. 143v–44; cf. *Lavin*, n. 95 for full text. The Humanist Francesco Filelfo remembered the tragedy by dedicating to Ottaviano his consolatory oration 'Per consolare Jacopo Antonio Marcello della Morte del Figliuolo Valerio', signed and dated 25 December 1461, Bibl. Vat. MS Lat. Vat. 1790 (ed. G. Bennaduci, Tolentino, 1894). Strangely enough, one year before Bernardino died, Ottaviano commissioned a treatise on the causes, symptoms, and treatment of the plague: Bibl. Vat. MS Urb. Lat. 1430. 'Tractus contra pestem' by Lodovico da Fossombrone Nesutiis, dated 5 October 1457.

44. *Cronaca mantovana di Andrea Schivenoglia, 1446–84*, ed. C. d'Arco (Raccolta di cronisti e documenti storici lombardi, vol. II, ed. G. Müller), Milan, 1857, pp. 131f.: 'De questo sig. mes. Carlo remaxe uno fiolo bastardo, el qual era de anij cercha 16 belo, grando, biancho; ogne homene ne dicea de li soij belezij: in di anij 16 o 20 luij vene gobo molto forte. El sig. mess. lo marchexo lo tenia in corte con una certa provixioncela. et questo fiolo de mes. Carlo avia nome mes. Vangelista.' Further, F. Amadeo, *Cronaca universale della città di Mantova* (late seventeenth century), eds. G. Amadei, E. Marani, G. Praticò, Mantua, 1955, vol. II, p. 84; Vangelista, born to a certain Dionigia N.N. in 1440, was '. . . bello fuor d'ogni credere. E questo in età di soli anni 16 mostrava animo guerriero e generoso e fu così caro al Marchese Lodovico che, quando egli fece venire a Mantove l'anno 1456 gli altri suoi nipoti colla loro madre Rengarda, presesi di sè medesimo questo Vangelista, provvedendolo d'un sufficiente appannaggio. Ma due anni in una malattia assai grave divenne mostruosamente gobbo e inabile del corpo suo, perdendo tutte le sue bellezze.' See also vol. II, pp. 285, 287.

45. 'Berardino Eburneo Adolescêtu Mci Octavii Filio,' Bibl. Vat. MS Urb. Lat. 373, fols. 121v–22. See above, note 44, for the passage in Schivenoglia's chronicle.

46. Cf. *Coins of the Roman Empire in the British Museum*, intro. H. Mattingly, London, 1940–50, vol. III, p. 93, pls. 16, 19, nos. 449–55.

47. W. Haftmann, *Das italienische Säulenmonument* (Beiträge zur Kulturgeschichte des Mittelalters und der Renaissance, vol. LV) Leipzig-Berlin, 1939, pp. 95ff., who also relates the column-monument to other judgement scenes.

48. The inscription reads: *Saluti Patriae et Christianae Gloriae, E.S.S.P.* (The last four letters are probably an abbreviation for *Ex sententia Senatus populi*, by decree of the senate of the people).

49. W. Bombe, 'Die Kunst am Hofe Federigos von Urbino,' *Monatshefte für Kunstwissenschaft*, vol. 5, 1915, p. 470, was the first to call attention to its pertinence for the Urbino panel; see also *Lavin*, p. 333, ns. 61–4.

50. Throughout the Epistles, but specifically, for example: Romans v, 2–3; Ephesians iii, 13; II Corinthians xi, 30; xii, 5, 9.

51. For examples of prognosticons and horoscope drawings of the sixteenth century see R. Taylor, 'Architecture and Magic: Considerations on the *Idea* of the Escorial', *Essays in the History of Architecture Presented to Rudolf Wittkower*, eds. D. Fraser, *et al.*, London, 1967, pp. 81–109, figs. 30–33. For the mathematical symbolism of the geometric pavement, see R. Wittkower and B. A. R. Carter, 'The Perspective of Piero della Francesca's "Flagellation"', *Journal of the Warburg and Courtauld Institutes*, vol. 16, 1953, pp. 294ff. For astrological constellations (Mars, Jupiter, and Venus) represented as eight-pointed stars, see the medal of Federico da Montefeltro reproduced in G. de Tervarent, *Attributs et symboles dans l'art profane, 1450–1600*, Geneva, 1958, vol. I, p. 5, fig. 1.

52. Cf. R. Wittkower, *Architectural Principles in the Age of Humanism*, London, 1962; New York, 1965.

53. K. Clark, *Piero della Francesca*, London, 1951, p. 19; see also C. Gilbert, *Change in Piero della Francesca*, Locust Valley, N.Y., 1968, for a new analysis of the internal dating of the Arezzo cycle.

54. In 1473, cf. J. Dennistoun, *Memoirs of the Dukes of Urbino*, London, 1851, ed. E. Hutton, 1906, vol. I, p. 51 n.

55. Cf. P. Rotondi, *The Ducal Palace of Urbino*, London, 1969, pp. 85ff., pls. 224–36, and fig. 45. Rotondi suggests that the chapel's decoration was influenced by Piero's painted architecture.

56. The reader should be aware that the effect I am describing is not apparent in illustration 52 since the photograph used in this montage shows *The Flagellation* not from above but at eye-level.

57. The author is about to publish a study on the Sigismondo Malatesta fresco.

58. For reconstructions of the space in the Brera Madonna see M. Meiss, with T. G. Jones, 'Once Again Piero della Francesca's Montefeltro Altarpiece', *Art Bulletin*, vol. 48, 1966, pp. 203-6 and J. Shearman, 'The Logic and Realism of Piero della Francesca', *Festschrift Ulrich Middeldorf*, eds. A. Kosegarten and P. Tigler, Berlin, 1968, pp. 180-86; for the significance of the space see M. A. Lavin, 'The Altar of Corpus Domini in Urbino: Paolo Uccello, Joos van Ghent, Piero della Francesca', *Art Bulletin*, vol. 49, 1967, pp. 19ff., and idem. 'Piero della Francesca's Montefeltro Altarpiece: A Pledge of Fidelity', *Art Bulletin*, vol. 51, 1969, pp. 367-71.

59. For discussion of some examples showing the formal influence of the 'scale reversal' in *The Flagellation*, consult C. Gilbert, *Change in Piero della Francesca*, Locust Valley, N.Y., 1968, p. 106 n. 58.

60. M. A. Lavin, 'The Altar of Corpus Domini', pp. 10-19.

List of Illustrations

Color plate: *The Flagellation.* By Piero della Francesca, *c.* 1460. Tempera on panel, 58·4 x 81·5 cm. Urbino, Ducal Palace. (Photo: Franco Rigamonti.)

1. *The Flagellation.* By Piero della Francesca, *c.* 1460. After restoration 1969. (Photo: Istituto Centrale del Restauro, Rome.)

2. *The Flagellation.* By Piero della Francesca, *c.* 1460. After restoration 1952. (Photo: Gabinetto Fotografico Nazionale, Rome.)

3. Detail of 1.

4. Detail of 1.

5. *The Flagellation.* By Lorenzo Ghiberti, 1417–24. Bronze. Florence, Baptistery, North Door. (Photo: Alinari)

6. *The Flagellation.* Sienese School, 15th century. Panel. Siena, Baptistery. (Photo: Alinari.)

7. *The Flagellation.* School of Pietro Lorenzetti, *c.* 1325. Fresco. Assisi, San Francesco, Lower Church. (Photo: Alinari.)

8. *The Flagellation* (detail from altarpiece). Sienese School, 14th century. Panel. Borgo San Sepolcro, Cathedral. (Photo: Frick Art Reference Library.)

9. *The Flagellation.* Pisan School, 14th century. One side of Processional Panel. Pisa, Museo Civico. (Photo: Anderson.)

10. Plan of visible ground in Piero della Francesca's *Flagellation.* (Drawing by Thomas Czarnowski.)

11. Reconstructed plan and elevation of the foreground and Praetorium in Piero della Francesca's *Flagellation.* (From Wittkower and Carter, *Journal of the Warburg and Courtauld Institutes*, vol. 16, 1953, pl. 44.)

12. *Perspective of an inlaid pavement.* By Piero della Francesca. Pen and ink. From 'De prospectiva pingendi'. Parma, Biblioteca Palatina. (Photo: Vaghi.)

13. Reconstructed plan and elevation of Piero della Francesca's *Flagellation.* (Drawing by Thomas Czarnowski.)

14. San Sepolcro Rucellai. By L. B. Alberti, 1457–67. Florence, San Pancrazio. (Photo: Brogi.)

15. Columns and trabeation of the Cappella Rucellai, now the entrance to San Pancrazio, Florence. By L. B. Alberti, 1457–67. (Photo: Alinari.)

16. Detail of 1.

17. Detail of 1.

18. Loggia Rucellai (after restoration), Florence. By L. B. Alberti, *c.* 1460. (Photo: author.)

19. Palazzo Rucellai, Florence. By L. B. Alberti, 1446–51: executed by Bernardo Rossellino. (Photo: Alinari.)

20. *Topographical view of Jerusalem*, from a manuscript of 1472. Bibl. Vat. MS Urb. Lat. 277, fol. 132v. (Photo: Vatican Library.)

21. *House of Pilate*, detail of 20.

22. Graphic description of location of secondary light source in Piero della Francesca's *Flagellation*. (Drawing by Thomas Czarnowski.)

23. Axonometric view of portions of Piero della Francesca's *Flagellation*. (Drawing by Thomas Czarnowski.)

24. Detail of 1. Right-hand foreground figure. (Photo: Franco Rigamonti.)

25. Detail of 1. Right-hand foreground figure, here identified as a portrait of Ludovico Gonzaga. (Photo: Franco Rigamonti.)

26. *Ludovico Gonzaga* (left profile). Anonymous, *c.* 1450. Bronze. Berlin-Dahlem, Staatliche Museen. (Photo: Museum.)

27. *Ludovico Gonzaga* (obverse of medal). By Pisanello, 1447–8. Bronze. (From G. F. Hill: *A Corpus of Italian Medals of the Renaissance before Cellini*, London 1930, vol. 1, p. 11, no. 30.)

28. *Ludovico Gonzaga*. Cast of bronze medal by Pietro da Fano, 1452–7. (From G. F. Hill: *A Corpus of Italian Medals of the Renaissance before Cellini*, London 1930, vol. 1, p. 76, no. 407.)

29. *Ludovico Gonzaga* (right profile). Anonymous, *c.* 1450. Bronze. Berlin-Dahlem, Staatliche Museen. (Photo: Museum.)

30. *Ludovico Gonzaga*, detail from the *Meeting of Ludovico Gonzaga and Cardinal Francesco Gonzaga*. By Andrea Mantegna, *c.* 1470. Fresco. Mantua, Castel San Giorgio, Camera degli Sposi. (Photo: Anderson.)

31. *Ludovico Gonzaga*. Anonymous, *c.* 1450. Bronze. Berlin-Dahlem, Staatliche Museen. (Photo: Museum.)

32. *Ludovico Gonzaga*, detail from the *Gonzaga Court Scene*. By Andrea Mantegna, *c.* 1470. Fresco. Mantua, Castel San Giorgio, Camera degli Sposi. (Photo: Anderson.)

33. Detail of 1. Left-hand foreground figure, here identified as a portrait of Ottaviano Ubaldini. (Photo: Franco Rigamonti.)

34. *Byzantines*. By Pisanello, 1438. Drawing. Paris, Louvre. (Photo: Museum.)

35A. *The Arrival of Emperor John Paleologus and his Entourage in Italy*, detail of the doors of St Peter's. By Filarete, 1445. Bronze. St Peter's, Rome. (Photo: Vatican Photographic Archive, after cleaning.)

35B. Detail of 35A. (Photo: Anderson.)

36. *Astrology* (destroyed). By Joos van Ghent, *c.* 1475. Panel. (Photo: Anderson.)

37. Detail of 36. Portrait of Ottaviano Ubaldini. (Photo: Staatliche Museen, Berlin Dahlem.)

38. *Ottaviano Ubaldini.* Anonymous, post 1474. Marble. Mercatello sul Metauro (Marche), San Francesco. (Photo: Gabinetto Fotografico Nazionale, Rome.)

39. Detail of 1.

40. *Adoration of the Magi*, detail from the Linaiuoli Triptych. By Fra Angelico, 1433. Panel. Florence, San Marco, Pinacoteca. (Photo: Alinari.)

41, 42, 43. Details of 1. Central figure of foreground group, here identified as Allegory of the 'Beloved Son'. (Photo: Franco Rigamonti.)

44. Reverse of 27.

45. *Gonzaga Court Scene*: detail, here identified as a portrait of Vangelista Gonzaga. By Andrea Mantegna, *c.* 1470. Fresco. Mantua, Castel San Giorgio, Camera degli Sposi. (Photo: Anderson.)

46. Detail of 1.

47. *St Catherine exhorting the Emperor.* By Masolino, *c.* 1428. Fresco. Rome, San Clemente. (Photo: Alinari.)

48. *Statue of David.* By Domenico Ghirlandaio, 1483-6. Fresco. Florence, Santa Trínita, Sassetti Chapel, outer pier. (Photo: Bazzechi.)

49. *Sublimità della Gloria.* Woodcut. From C. Ripa: *Iconologia*, Padua, 1618, p. 512.

50. *The Queen of Sheba's visit to Solomon.* By Piero della Francesca. Fresco. Arezzo, San Francesco. (Photo: Soprintendenza, Florence.)

51. Cappella del Perdono, Ducal Palace, Urbino. (From P. Rotondi: *The Ducal Palace of Urbino*, 1969, fig. 226.)

52. Photographic montage, Piero della Francesca's *Flagellation* as altar frontal in Cappella del Perdono, Ducal Palace, Urbino. (Photo: Phillip Evola.)

53. *Sigismondo Malatesta before St Sigismund*, 1451. Fresco. Rimini, San Francesco. (Photo: Soprintendenza, Florence.)

54. *St Jerome and Gerolamo Amadi.* By Piero della Francesca. Panel. Venice, Academy. (Photo: Osvaldo Böhm.)

55. *Madonna and Child with Saints and Federico da Montefeltro.* By Piero della Francesca. Panel. Milan, Brera Gallery: (Photo: Museum.)

56. *St Francis presenting his Rule to Pope Honorius III.* By Domenico Ghirlandaio, 1483-6. Fresco. Florence, Santa Trínita, Sassetti Chapel. (Photo: Alinari.)

57. *Communion of the Apostles.* By Joos van Ghent, 1473-4. Panel. Urbino, Ducal Palace. (Photo: Gabinetto Fotografico Nazionale, Rome.)

Index